sunday afternoon, looking for the car

theaberrant**art**of**barrykite**

alan bisbort

POMEGRANATE

Published by Pomegranate
Box 6099, Rohnert Park, CA 94927

Pomegranate Europe Ltd.
Fullbridge House, Fullbridge
Maldon, Essex CM9 7LE, England

ISBN 0-7649-0362-4
Pomegranate Catalog No. A903

 Library of Congress Cataloging-in-Publication Data

Bisbort, Alan, 1953-
 Sunday afternoon, looking for the car : the aberrant art of Barry
Kite / Alan Bisbort.
 p. cm.
 Includes index.
 ISBN 0-7649-0362-4 (pbk.)
 1. Kite, Barry--Criticism and interpretation. 2. Collage--United
States. 3. Appropriation (Art)--United States. I. Title.
N6537.K54B55 1997
709'.2--dc21 97-14852
 CIP

Designed by Rod Wallace / Q Design

Printed in Hong Kong

06 05 04 03 02 01 00 99 98 97 10 9 8 7 6 5 4 3 2 1

First Edition

the**contents**

Perhaps the most cogent commentary on the art of Barry Kite was provided by a potential customer who stumbled upon his work at an art fair, having spent the day looking at landscapes, seascapes, kittens, and other assorted kitsch. While staring—half bemusedly, half fearfully—at a rendering of a Ken doll being shot in the gut by Jack Ruby (*Conspiracy*), the man asked in all sincerity, "Is it okay for me to put this on my wall?"

Unknowingly, perhaps, this customer (yes, he eventually bought the piece) may have put his foot on the land mine that is Barry Kite's vision. Barry calls his work Aberrant Art. Aberrant is defined as "that which strays from the right, normal, or usual course"; art, of course, has never been successfully defined, but we all know what we like, don't we?

Behind Barry's likeable arrangements and painterly palette lurks danger. For starters, because his work encourages viewers to stray off the usual course, there's a threat that they may stray too far and never get back to . . . ah, but there's the rub. Back to what? Normalcy? *USA Today* and televised idiocy? Chockablock suburbia and corporate strangulation? Downsizing and upscaling? Disneyworld?

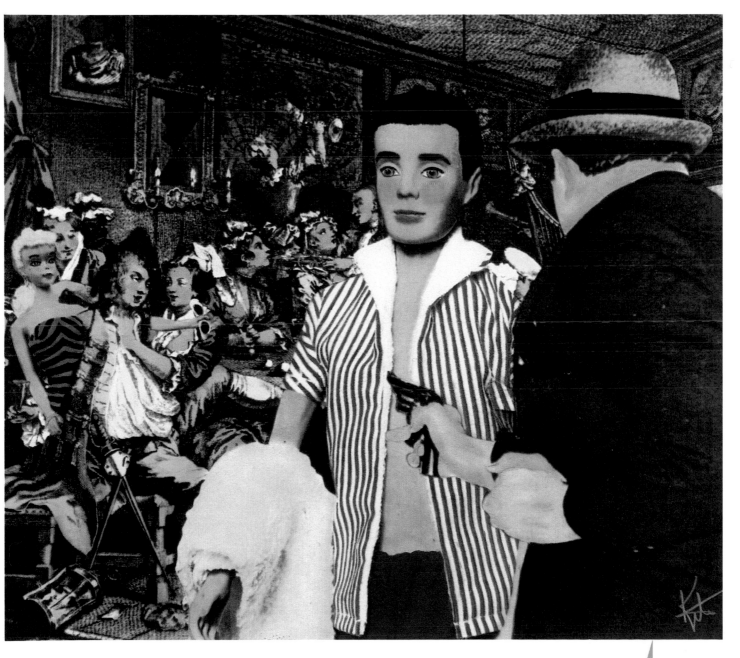

Conspiracy
(formerly *Ken Has a Religious Experience*)

There is something vaguely familiar about all of Barry Kite's pieces that allows for an ill-advised zone of security—not unlike the deterrent cushion of an airbag inside the steering wheel of a speeding automobile. Are you willing to test that airbag by, say, suddenly swerving the car into the abutment of a bridge?

Likewise, nothing is safe about Barry Kite, although more often than not reactions go no further than the chuckle elicited by the Duchampian sight of, say, Mona Lisa playing cards (*Whose Bet?*, page 79), or Santa being plugged by a big game hunter (*Damn!*, page 80), or Christina being hauled away to the nuthouse (*Christina Removed for Observation*, page 67). The truth of the matter is that police caution tape should be stretched across the scene of Barry Kite's aberrations. His goal goes beyond the belly-laugh (see "A Note on Method," page 14), though that response is okay with him, too, up to a point. He just can't rest easy on Valesquez's or Vermeer's laurels. He takes no comfort from Cubism; it doesn't go far enough. He's not enamored of abstraction, either, because each of his pieces tells a quite explicit story, thank God. Surrealism is only the half of it. In short, Barry Kite has declared a one-man war against all iconography, art, photography, current events, and celebrity.

Like Don Quixote, Barry Kite wages war on the windmills of art history, art criticism, and art business. But Barry Kite has a bit of Sancho Panza in him, too. If he can't defeat the windmills, he simply cuts them into pieces with his X-Acto knife and transforms them from an irresistible force into a movable object.

You might be asking yourself, what drove Barry to such straits to begin with? From all outward signs, he is a remarkably pleasant fellow, blessed with a keen and playful mind and lots of friends (well, at least, lots of people show up at his open studio shows, and he's beginning to think it's the free wine . . .). He loves dogs and performs in community theater productions. Though he hesitates to admit he owns a television, he once had a bit part in an episode of *Unsolved Mysteries* (or, rather, his feet did) and ditto with *Nash Bridges* (the back of his head).

What makes Kite remarkable is his unique relationship with his customers—one of the most hands-on and unabashedly egalitarian of any serious contemporary artist in the country. He personally sells every one of his

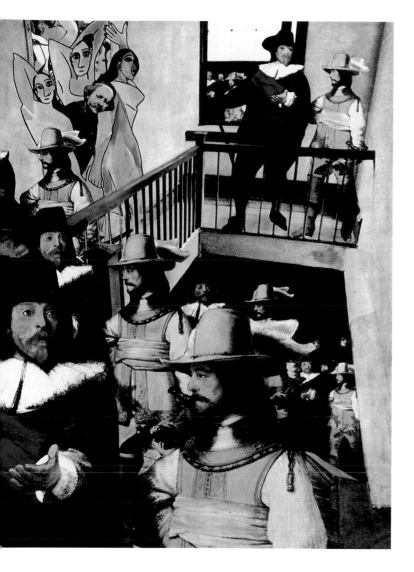

eration than should probably be admitted in public:

• *This Is Not a Book* (with apologies to René Magritte)

• *Cut This Book* (with apologies to Abbie Hoffman)

• *Bait and Switch in the Garden of Eden*

• *Rude Awakening in the Hereafter*

• *Flea Market of the Gods*

Of these, only the latter was provided by Barry Kite, the artist under question. Wait a minute. That's one of his, isn't it? *Artist Under Question*. Well, if it's not, it should be. The art establishment and museum curators would sure like to put Mr. Kite under question. They would also, no doubt, enjoy the possibilities of titles such as *Artist Being Detained* and *Artist Being Compromised*. But what would they make of his *Artist Investigating Disturbance in Hall*, or *Artist With Rented Car*? Or *Still Life With Kleptomaniac*, or . . . wait, wait, wait! Is there a thief loose in art's henhouse?

Yes, and his name might be Barry Kite. Might be. Can we afford to take that chance?

pieces at art fairs across the country. He also mans an 800-number (180099KITE!) at all hours, just in case any of his patrons has a question about his work—like the distraught woman who called at 4 a.m. to ask about the meaning of a $1.00 postcard (he was on the phone with her for twenty minutes).

While none of the following titles was used for this book, each was given more consid-

Artist Investigating Disturbance in Hall

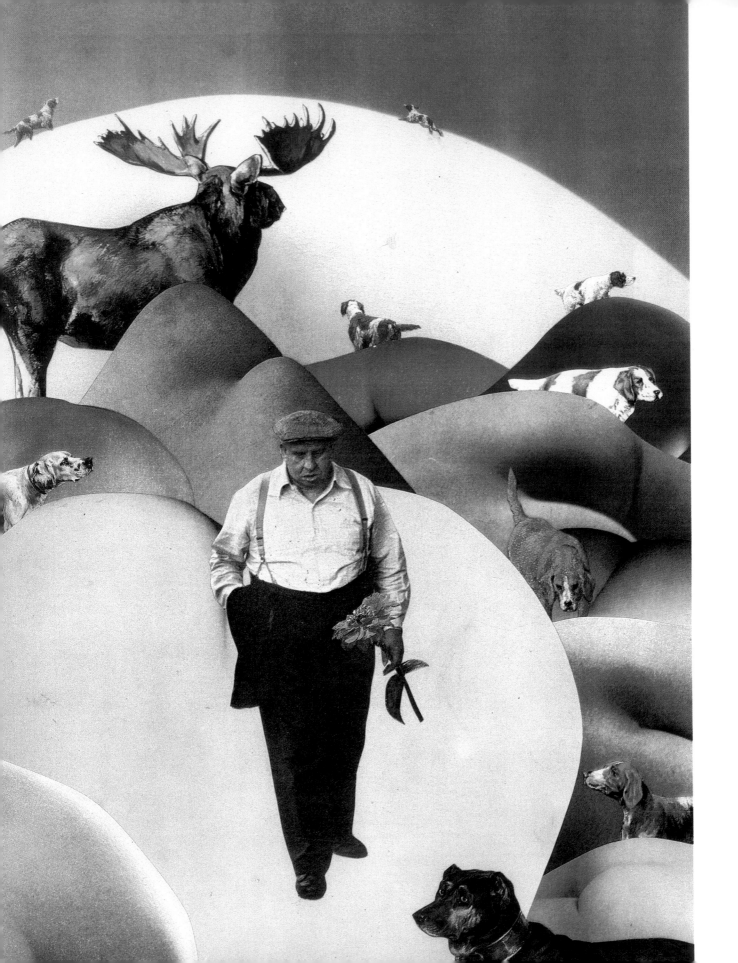

searching for his moose

Barry Kite's journey to the art of collage was as fortuitous as an encounter between a poet and a moose on a dissecting table.* Indeed, the title of his collage *A Poet in Search of His Moose* might very well describe his life's roundabout journey. Like most of his breed, he was not trained to be an artist—he wasn't collage-educated, you might say. He did, however, earn a Bachelor's degree in 1971 at UCLA, from the same film department that had unleashed Jim Morrison and Ray Manzarek of the Doors a few years earlier.

And yet, even Kite's decision to attend UCLA was arrived at by collage-like chance. He'd grown up in the Chicago area, and when it came to choosing a citadel of higher learning, he picked UCLA from among several

Note: The similarity to the famous pre-Dada statement "As beautiful as the fortuitous encounter of a sewing-machine and an umbrella on a dissecting table" is fully intended. That line, from Les Chants de Maldoror *by Comte de Lautreamont [née Isidore Ducasse] (1846-1870), is a seminal utterance for all collage artists, and was used as a cornerstone of André Breton's several surrealist manifestos.*

schools he had in mind because it had been ranked Number 1 in *Playboy's* "Best-Looking Coeds" poll the year before. Similarly, he arrived at his film degree by a process of elimination. Actually, it was a benign accident:

> I didn't have a major, and I didn't want to stand in line to get my class assignments. I decided that whatever was open the next morning would be what I'd take. By then, only "TV Writing" and "Film Writing" were left. So, I wound up a film student, with film writing my specialty.

The same fortuitous encounter with reality faced Kite when he finished college with his film degree. He was living in Santa Monica just down the hill from Hollywood, with a draft deferment for health reasons (a bad knee, the result of a college wrestling match). Having proven to be a quick study in film school, the opportunities were at hand for him to enter "the industry" and find his niche along the celluloid assembly line (see *Quality Control* on page 47 for further enlightenment).

Instead, he left the country for the next several years.

First, he went to Sweden. Though only the second most popular haven for American

draft resisters after Canada, Kite, in his inimitably contrary way, went there to meet a friend. Soon enough, he'd embarked on a budding career as a Swedish pizza cook, which was cut short after three months when he was required to leave the country to reapply for a work permit. Unfortunately, La Pizza changed its mind and the work permit was denied, stranding our hero on the Continent.

Next, Kite found himself in Munich, Germany, just prior to the 1972 Olympiad. Preparatory work for the Games was plentiful, so Kite got in line at the municipal employment agency behind hundreds of Turks, Slavs, Africans, and Asians. But, as witnessed by his choosing of college majors, Kite—though he loves other cultures—has a thing about standing in lines. He is constitutionally incapable of standing in lines. He decided, right then and there, to create his own one-man line. Of frogs.

That is, he began making frogs out of beanbags. "Soft sculpture," he called them. Purchasing his green velvet fabric by the roll, he filled his eye-catching creations with dried millet. He sold them, for the equivalent of three bucks apiece, on the sidewalks of Schwabing, the hip nightclub district of Munich, not far from where Adolf Hitler got his start as a painter of tourist postcards. (The demonic ghost of der Führer would soon resurface when several Israeli athletes were murdered by terrorists, a cautionary blight on all Olympiads since).

Meanwhile, Kite earned the nickname "Frog King of Munich," not only for the number of his creations he was making and selling, but for his engaging street manner. He'd conceived a way for his green velvet frogs to perform tricks, which enticed many passersby and transfixed many others. Kite's only concern at the time, in fact, was that some pedestrians were becoming too transfixed by his frogs, almost falling into construction ditches and open manholes, their oblivious wonderment so complete. It was a bit like the Monty Python "killing joke" routine, art that's so intriguing that it can send you down a manhole. While that's a nice metaphor for Kite's collages, he has never intended to cause physical harm (except, perhaps, cortical lesions).

Okay, the "Frog King of Munich" was twenty-two years old, on his own in the world, and making an honest living selling his handiwork. A quarter of a century later, in 1997, he insists, "What I'm doing now is pretty much the same thing I was doing then. I've been a street vendor since I was twenty-two."

No one can dispute that claim. Nowadays, he circulates the country in his van more often, and more circuitously, than Jack Kerouac or John Steinbeck, attending art fairs and paying house calls on his regular clients and, figuratively, selling his wares on the street.

But we get ahead of ourselves. Long before he was making and selling his collages, the trajectory of Kite's life read like a digest of *Marco Polo's Travels.* After Munich, he hooked up with a friend who'd just purchased a Land Rover.

We drove overland through Pakistan and India, finally selling the car in Nepal. I flew to Bangkok, hitched down to Malaysia, then took the ferry to Sumatra and bussed through the jungle to Java and Bali. Things happened. I got hepatitis in Indonesia. I wound up in Australia and was out of money, so I began making frogs

again in Sydney. Then I went to New Zealand, and did the same thing in Christchurch. Traveling solo, making frogs. Then I went to Japan to sell frogs and ended up teaching English.

The two years Kite spent in Japan had a profound influence on his artistic vision. (See *Tsunami, Pont Neuf* and *Grace Before Sushi,* pages 37 and 39.) All the while he'd been traveling, he couldn't help but notice that he had a remarkable facility for language, a direct offshoot of the love of words he'd developed as a budding poet. He had already learned Swedish and German, but in Japan his horizons expanded in all directions.

In Tokyo, I taught English to classes as well as private students. I went to Sapporo in northern Japan for a time, to get away from Tokyo where everyone spoke English. I wanted to really study Japanese. I was fascinated with the Chinese character pictographs used in written Japanese— written words evolving from images. In writing, you are limited to the vocabulary of what ever country you find yourself inhabiting. Like Sweden, which has one of the smallest vocabularies in the world. It's

*about 11,000 words. Or is it 11,000 people
who live in Sweden? I forget which. At any
rate, it's a small vocabulary. After three
months, I was able to plod my way
through Ray Bradbury's Fahrenheit 451 in
Swedish. I could also tell one Swedish joke
in Strindbergian dialect.*

In college, he had approached the visual medium of film through the linear, analytical medium of words. And he had enjoyed the immediate feedback of the classroom.

*I thought I was going to be a writer. But all
the while I was traveling, I didn't keep a
journal. A writer who didn't write. I didn't
take photographs either. If you had a
camera you had to worry about people
stealing it. If you had a journal, you had
to worry about losing it. But all the while
I'm traveling, I'm thinking, "If I'm going
to be a writer, how come I'm not writing
about all this?" I had once heard that be-
fore you can really write about an experi-
ence you have to wait seven years. So, sev-
en years after I got back from my first
travels, I sat down and said, "Well, now
it's time." And I still couldn't write.*

On returning to the States, Kite moved to Berkeley, home of the Free Speech Movement, but not the free frog movement.

*I wanted to sell frogs on the street here. But
you needed a license, even in Berkeley.
Anywhere else in the world, you just set up
and start selling, but here, in my own
country, no.*

Out of necessity—and because his job history was so quirky—Kite began selling jewelry on the street. He shared a vending spot with a married couple who made jewelry from beads, putting fancy price tags on unfancy merchandise. Though they offered Kite half a tabletop on which to display his frogs, the homemade, affordable, and unique wares of the Frog King of Munich didn't hop off the tabletop the way they had in Europe.

Though a sobering experience for him, Kite was at least able to find a niche in the jewelry business. And he remained there—selling antique and estate jewelry—for the next nine years, both as a street vendor and in his own shop on Pier 39 in San Francisco. All the while, he was decorating the walls of his shop with his collages and giving them away as gifts to his friends. And he was studying languages. A precipitating event occurred when,

for reasons he's still not clear on, he took a hand-coloring photography class at a Berkeley senior citizens center, followed by a class in darkroom photography. He was suddenly fascinated with the aesthetics of making art, and challenged by the possibilities of art approaching the imagery of poetry.

Kite's poetry was, as stated, a direct result of his lifelong love affair with words, an unstoppable flow of images and ideas still looking for a suitable medium. Pursuing his muse through the bars and coffee shops of Berkeley's vibrant poetry scene, he would write by day and perform his work in the evenings at open microphone readings or scheduled events. This, however, could be dispiriting.

The most depressing thing was to go last and be forced to listen to all these other poets. By the time I got to read, the crowd was stinking drunk, with nowhere else to go. I lost respect for the audience and found myself thinking, "Why should I amuse or entertain these people?" My poetry was like my art is now. Any way to wake them up, anything to get their attention.

In retrospect, of course, the many different experiences, impulses, and visions of Barry Kite seemed, like water seeking its level, to ultimately find their perfect medium in collage. But he still had to make that final decision, draw that line in the sand.

In your twenties, you absorb experience, just soak it all up. But when you're in your thirties, you have to be a bit more specific. I'd been trying to be a writer for years, but it wasn't working. I couldn't draw. I couldn't paint. But I decided to be an artist anyway, integrating the three different media I was working in: photography, painting, and poetry.

This was not, of course, a conscious decision. It wasn't like going into beekeeping or wine making or real estate. Collage, more or less, chose Barry Kite. Not vice versa.

I realized that I could not react to a blank piece of paper, or a blank canvas. I reacted to what was already out there, the appropriated images of the world. I need something to begin with, and then I can manipulate and recycle it into something totally new. Maybe I do this from fear. Even now, I think to myself, "I should be writing . . . because I was trained to be a writer." And I'll sit down with a blank piece of paper and an

inkpen and . . . I'll end up leaving the room to go cut up images from old books and magazines. I feel the most comfortable, the most at peace doing that, in my room with my debris.

Here he is, then, a poet in search of his moose.

a note on method

Only a spoil sport or a doofus would ask a magician how he pulls a rabbit, or a moose, out of a hat. While Barry Kite's collage magic requires a certain amount of sleight of hand, the process of attaining his final image is a fascinating and vital part of the creative act. What some people would call the original is just his jumping off point. A quick diversion here to examine the process could enhance one's viewing pleasure of the images that follow. Or maybe you're already a satisfied customer and a cigar is just a cigar. Well, check this out anyway.

First, the title of each work is not randomly selected or tacked on as an afterthought. To Kite, the image and the title are one and the same work, and their theme is "the tension created by the relationship between the written word and the visual stimulus." In his earliest collages, in fact, Kite gave words equal footing on the canvas with the images. The idea is to make the viewer really look, not just see. Ideally, he wants viewers to have an intellectual as well as an emotional experience—to use both parts of their brains simultaneously.

This thrust, of course, fights a battle against such overwhelming forces as TV and computers, and the passivity and laziness these media engender. Because of the kudzu-like proliferation of such mind-numbing stimuli, modern viewers have a subconscious tendency to dismiss any image or text that requires more than a casual glance. Or as Kite more politely puts it, "the presence of alternate interpretations calls for the use of painfully atrophied mental resources."

Second, Kite insists that images—especially the well-known iconographic images he uses in his collages—bring with them "their own baggage, with our own personal luggage mixed in." Thus, we each make different and personalized interpretations of these images.

This is, of course, a tenet of all great painting and literature," he continues. "But our contemporary mass-communication syndrome has so trivialized and homogenized such interpretations that it requires more shocking non sequiturs to jolt us back to our primitive roots (meaning, pre-TV), where we can once again free-associate and use neural pathways that have long been neglected.

Third, the visual aspect of Kite's imagery usually works on more than one level. As he describes it:

On the surface may be the excitement of the colors, the visual composition. Beneath that may be the humorous juxtaposition, an absurdity that brings a quick laugh. Then, there is the obvious symbolism. Often, I will use an image from a certain historic period in contention with an image representing a more modern period. The result may simply represent the objects displayed, or it may represent the specific artists, or those historic periods and the cultural baggage they carried. For example, we may be talking about the Inquisition, Victorian morals, or the Franco-Prussian War; or the Church, Queen Victoria's sex life, or Vietnam.

Finally, the physical process of making these collages is not a simple cut-and-glue proposition. The final work may go through any number of nearly alchemical alterations before the Kite signature goes on them.

First, I skim through my vast library of recycled art books and magazines. When an image attracts me, I immediately excise it with the use of an X-Acto knife and a cutting pad (thus, sparing the several pages on either side of the excised image). The fact that the image has attracted me creates a sense of incompletion. My mission then is to somehow give it an upgrade so that it can make the point it has always had the unfulfilled capability of making.

The cutting and pasting begins here, but it is first done where it is least messy—in my head. If the components that have initially attracted me are less then satisfying, I sort through the massive piles on my work table. If suitable partners are not found there, I return to my library and continue to skim, but this time I have a direction. This suggests my favorite analogy of the work that I do: I am the director assembling a cast of images to join my rep-

ertory company and assume different roles in interacting with that initially selected image. More often than not, the initially selected image doesn't even make the final cut, and is asked to leave as an entirely new scenario has taken shape. (That rejected image ends up on the work table for later use.) Much of my work day consists of pushing around and recropping these images until some sort of sense is made out of them. Ultimately, that "sense" is my "style."

Finally, something gets glued together. I then make a laser copy of this paste-up. The laser copy allows me to manipulate color and contrast, and to crop the image for the right composition. I then work on this copy with pen and ink, pencil and pastel. Occasionally, colored gels are incorporated into the process.

While most of the time, the visual part of the work is completed here, an occasional image will demand more extensive colorization. That's when I move into another art form, the painted photograph. The touched-up laser print gets rephotographed and enlarged to anywhere from

a 16" x 20" to 36" x 60" photographic print on a special textured fiber-based paper that is suited to absorb pigments. Using for the most part traditional hand-coloring techniques, I rub photo-oils into the print to achieve the desired effect. I may also incorporate pastels, ink, and acrylics to enhance the print, obliging me to refer to this process as hand-painting rather than tinting or coloring. My painting often is too heavy to be categorized with the subtlety of traditional hand coloring.

Or maybe you see something else?

the**plates**

visionary

In the wee hours of the morning, Barry Kite is sometimes visited by the ghost of René Magritte (1898–1967), the great Surrealist painter. Magritte's work was nothing less than an epiphany to Kite; actually, a double epiphany. The first was that art could be fun. The second was that a painting could call attention to itself *as a work of art*, the cornerstone of Kite's collage technique. This epiphany came in the unlikeliest of places, an undergraduate survey course in art history that Kite was required to take as a film major at UCLA. When he turned the page of his textbook to "Surrealism," he beheld Magritte's *The Treason of Images*, the now iconic 1929 painting of a pipe that includes the inscription "Ceci n'est pas une pipe" ("This is not a pipe").

As a poet and would-be writer, Kite was predisposed to think in words, but his film courses trained him to see the world as visual matter. Here, however, was an artist who communicated with words, symbols, and images, and in the process altered a viewer's perception of an image by reinforcing the idea that a picture is only a picture. Just as Einstein's theory of relativity changed the way we look at the universe, Magritte upset the entire applecart of art history. And he seemed to be enjoying himself in the process!

In *Visionary*, an homage to his mentor, Kite has whisked Magritte from his *Self-Portrait* and placed him in front of a photograph by Edward S. Curtis (1868–1952). The use of a Curtis photograph is equally enlightening. Curtis spent 30 years tirelessly, even obsessively, amassing a photographic record of Native American culture and daily life that eventually became part of his masterwork, the 20-volume *The North American Indian*. After his death, Curtis was slowly pecked apart by scholars and academicians for having posed a number of his "candid" shots, perhaps even the one Kite has borrowed here. A Curtis photograph reinforces some of the same questions raised by a Magritte painting. When, for example, is a photograph the "actual" truth and when is it artful manipulation? Can it be both simultaneously?

In Magritte's original self-portrait, he is looking at an egg while painting a chicken. In Kite's *Visionary*, Magritte is looking at a golf ball while painting a golf course. The golf course, in the wake of what Curtis called a "vanishing race of people," adds another level to the collage, bordering on social commentary. Indeed, all over the world, the sacred lands of indigenous peoples are being turned into corporate enclaves so perfectly epitomized by the unnatural, chemically generated greenness of a golf course putting surface. But then, as Kite would say, maybe you see something else.

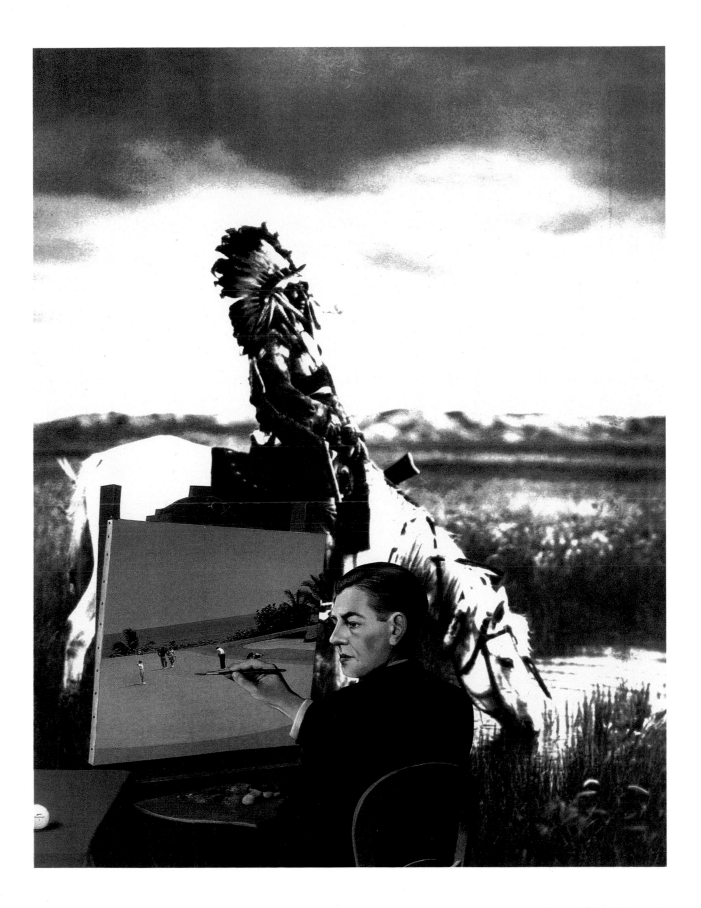

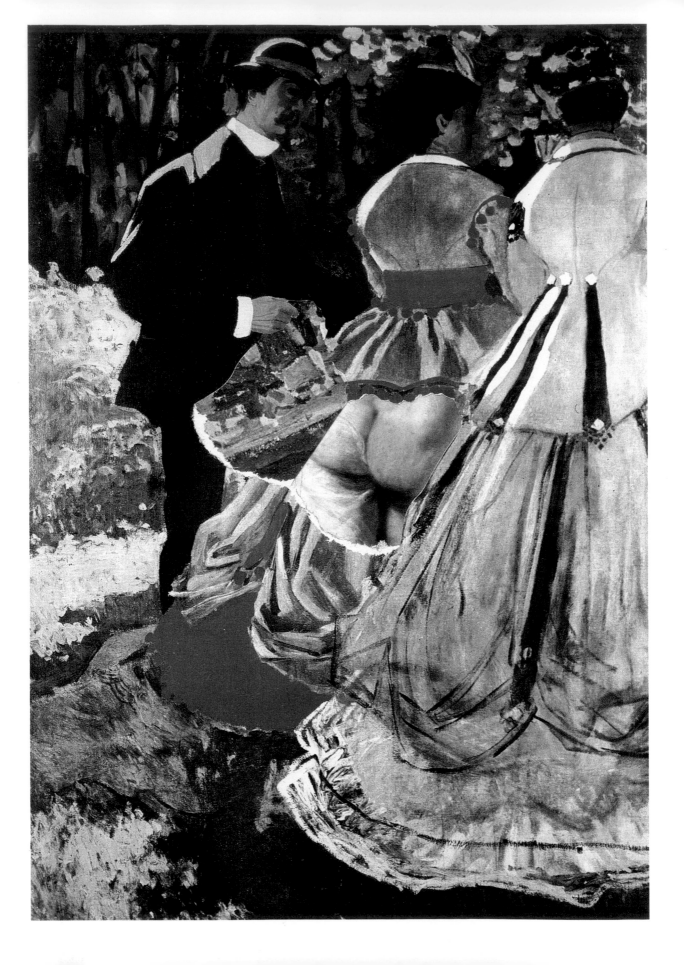

foundations of early impressionism

While the figures here were borrowed from Monet and Rubens, the work itself is another tribute to Magritte. The man who is ripping the foundation garments from the woman discovers—and reveals to the viewers—that the garments were just pages from an art history text after all. One of the great hurdles many viewers have to overcome about Kite's work is that he cuts many of his images from books, which to some is tantamount to flogging Bambi or beating babies. He himself has had to overcome the hurdle.

"I grew up revering books," he admits. "My uncle was a lawyer, and had one room of his house made into a library. When I was a kid, I could only look at the books if I was real careful. One of the biggest obstacles I've overcome in my adult life is the fear of being flayed alive and toasted like a marshmallow in Hell for the unforgivable sin of cutting a picture out of a book."

But something changed along the way, and it is tied in with lessons he learned from René Magritte. "Collage is like a Frankenstein-ian, re-creative act. I take the dead cadavers of other images and re-create a new one. Destruction being the first act. I realize that the commitment of this act has set me apart from a great percentage of the populace."

Barry Kite sees one of his jobs as divorcing the artist from the twin stultifying grips of art business and art criticism. When he appropriates the work of a great artist, he is not mocking it, or the artist. Rather, he sees the artists as being part of his "team." That is, "I've got all the stars and I'm the coach, and if you don't like the way a figure is drawn or painted, go complain to Titian or Rembrandt or Michelangelo."

cubicle-ism

In *Cubicle-ism*, he sees the best minds of Western art working for Fortune 500 companies, staring fixedly from behind their cell-block desks. All but Vermeer, who turns his back on the proceedings to concentrate on the CD-ROM version of his greatest hits.

Joining Johannes in his cubicle are the Mona Lisa (a reference to the allegation that it is Leonardo's self-portrait) and Vincent van Gogh, flirting with da Vinci by offering him/her one of his ears ("Try it with the French onion dip!"). The rest of the office lineup, starting at the farthest row of cubicles, from left to right, is: Toulouse-Lautrec, Matisse, Winslow Homer, and Rousseau; then Degas, Titian, Picasso, Whistler, Velasquez, and El Greco; and last, Monet, Cezanne, and Rembrandt. Not a bad lineup.

No sizes or perspectives have been altered from the found imagery for *Cubicle-ism*, with the eerie result that everyone seems to be staring directly at the viewer, as if caught in mid-mutiny against the reigning CEO. In a world increasingly dominated by corporations, is it really too farfetched to wonder whether today's Vermeers and van Goghs and Rembrandts aren't piddling away their talents inside a cubicle somewhere? Perhaps inside one of the thousands of high-rise business parks we see as we scoot across the mega-malled landscape in our contoured, climate-controlled love-machine-on-wheels.

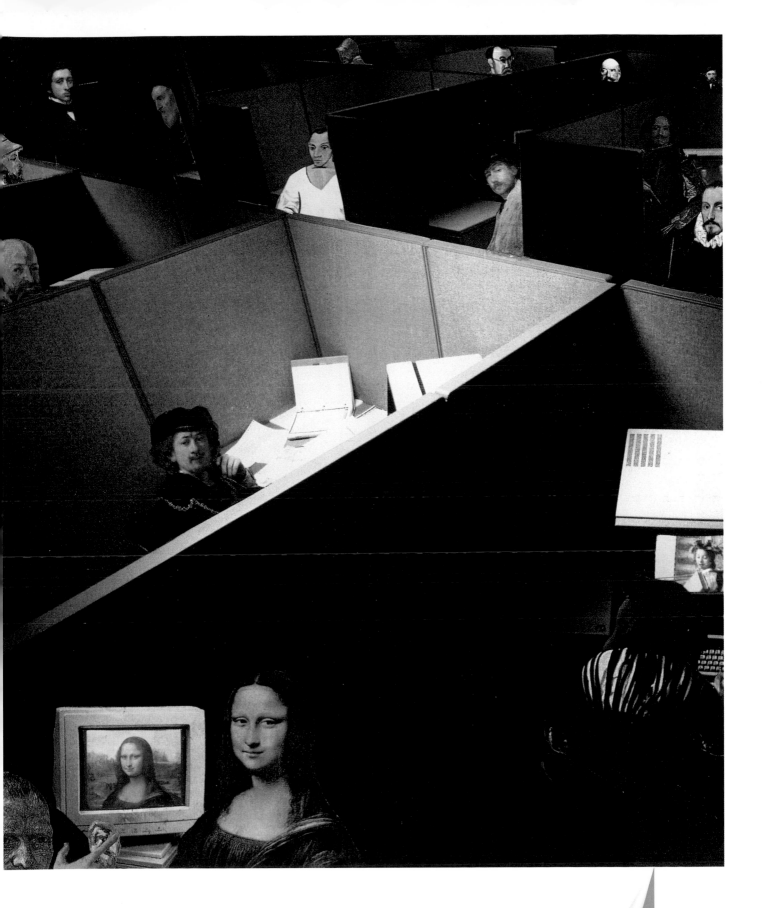

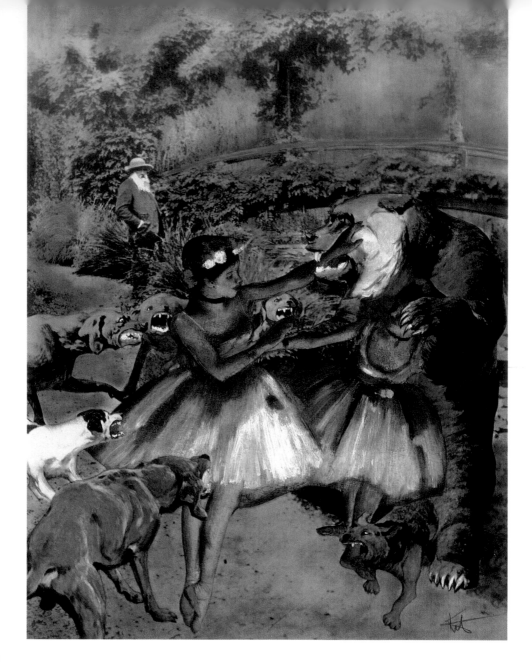

monet's dogs

Monet's Dogs is an all-time personal favorite of Barry Kite's, a large painted version of it having taken top honors at one of the first art competitions he entered. This is the dark underside of Claude, the opposite of what we've come to expect from him in museum gift shops across the universe. Monet can be seen in the background, preparing to cross the oriental bridge in his garden. He has warned his neighbor, Edgar Degas (1834–1917), to keep his dancers chained up, but it has done no good. They keep straying onto his property. What else can a poor painter do, except to sick his pack of hounds (and one grizzly bear) on the gals.

In real life, Kite loves dogs. And dancers.

the**sundayafternoon**series

As a child, Barry Kite was taken to the Art Institute of Chicago where he saw *Sunday Afternoon on the Island of La Grand Jatte* by Georges Seurat (1859–1891). This masterpiece of Neo-Impressionism made a deep and lasting impression on the lad, subliminally altering his way of viewing the world around him. *La Grand Jatte* (ca. 1884–1886) epitomized Seurat's goal of dividing representational art into its two components, color and light. To do this, he used thousands of points of paint—not to be confused with George Bush's thousand points of light.

Kite has made a number of collage homages to this early influence, five of which are included in the "Sunday Afternoon" series. One disclaimer from the artist: "My work is not based on the musical."

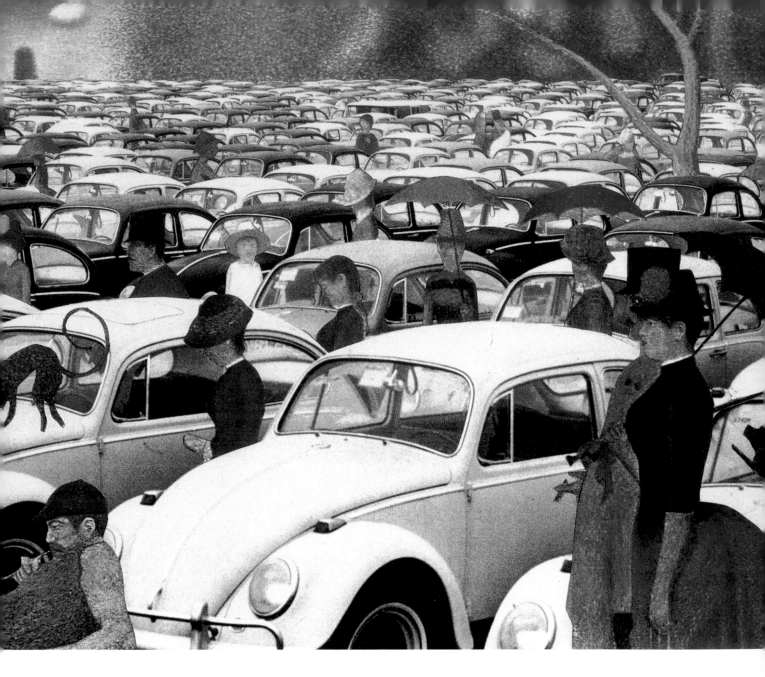

sunday afternoon, looking for the car

The flip side to beautiful Sunday afternoons in beautiful cities like Paris is that everyone wants a front row seat along the river. Of course, not everyone came down to the Seine by cab, train, or shoe leather. How else do you think they got there? A Volkswagen bug seems like the perfect Neo-Impressionist vehicle to Kite.

dinosaurs foraging for neo-impressionists in georgia o'keeffe's backyard II

The earliest in the Sunday Afternoon series, this was done in 1985, and it uses more Seurat components than those found in *La Grand Jatte*. What better place to have this grand soirée than on Georgia O'Keeffe's property, where the denizens can dance in the sand and trample over erotic flowers? Contrary to the title and rumor, Ms. O'Keeffe did not appear in *Dinosaurs Foraging for Neo-Impressionists in Georgia O'Keeffe's Backyard I*.

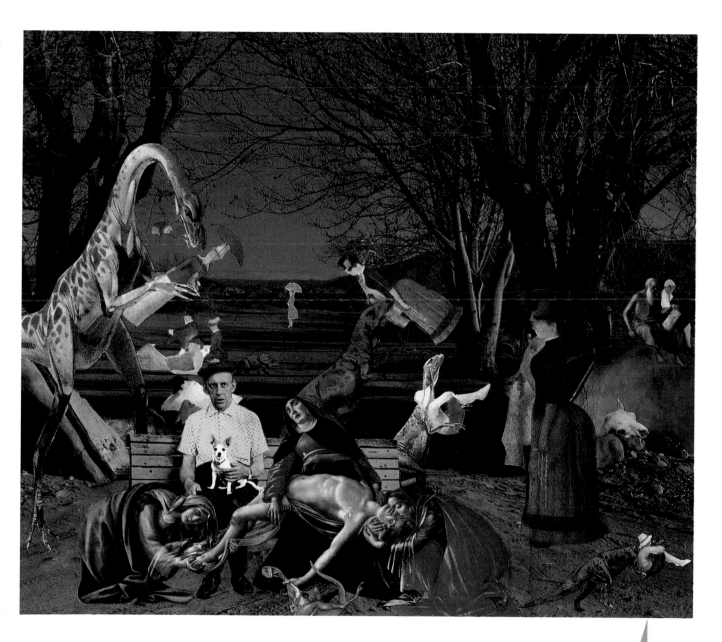

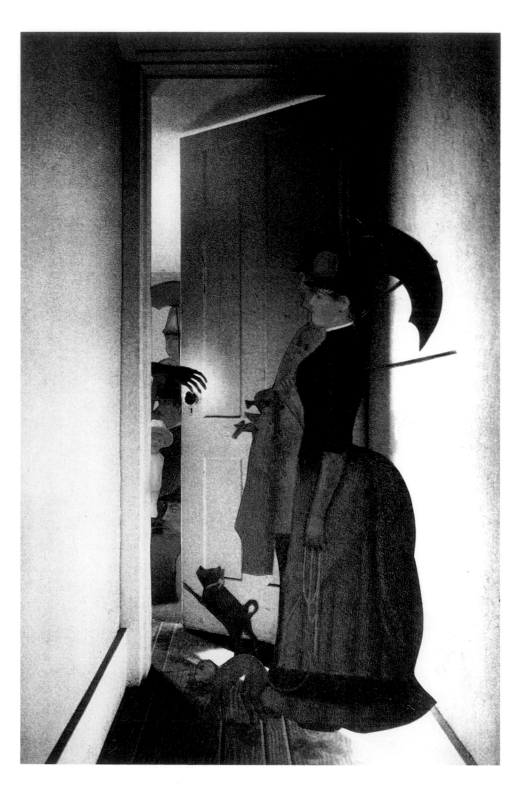

sunday afternoon in a small room

When it rains on La Grand Jatte, where do all the Neo-Impressionists go? A shabby building nearby offers a small one-room apartment for their clandestine meetings. Who picks up after the monkey and dog? Or is that a tiny pig?

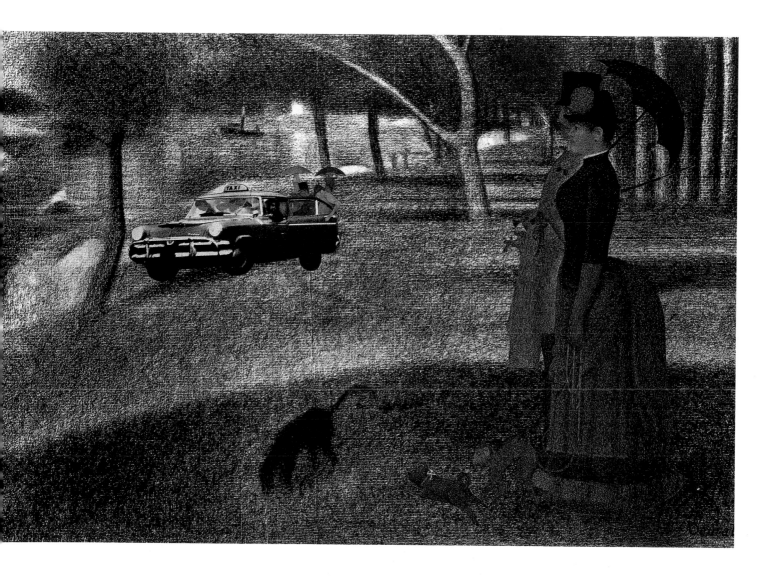

sunday afternoon, late

The background for this collage is one of several preliminary sketches in charcoal that Seurat made for the final painting. It is after 5 p.m. here, and Georges has packed up his paint and brushes.

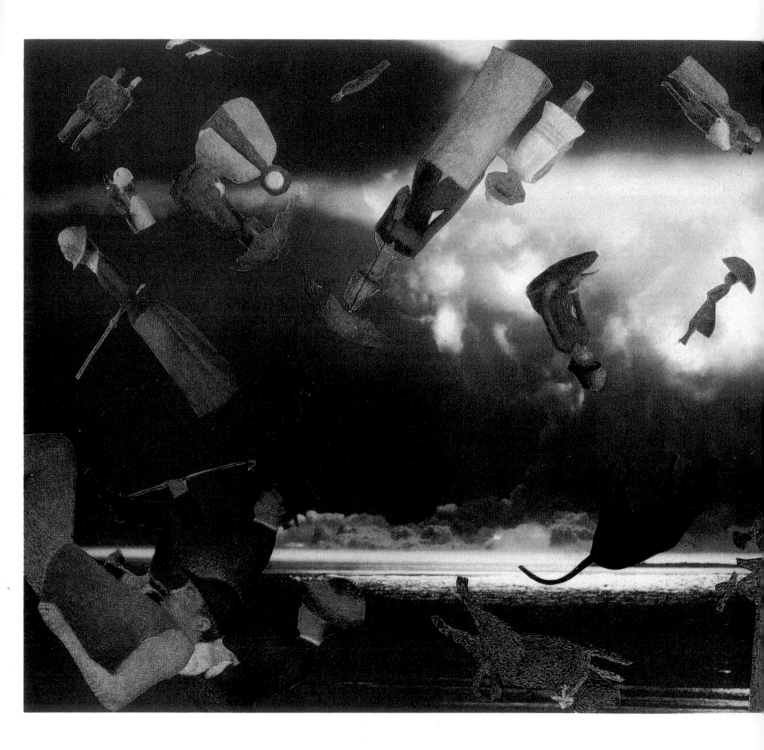

sunday afternoon, wrong island

Imagine taking a wrong turn that Sunday afternoon and confusing La Grand Jatte with another French island. Somewhere in the South Pacific perhaps. Maybe Greenpeace would like to use this as a recruiting poster?

haystacks, paris, night

Employing an unusual split-screen technique, Kite explores the edge between painting and photography in *Haystacks, Paris, Night*. The haystacks are provided by Claude Monet (1840–1926) while the Parisian streetscape comes via the lens of Brassai, the transplanted Hungarian whose book *Paris by Night* offers the best window on that city in the 1930s. This image is also a witty commentary on the "cult" of Claude Monet that has emerged in the decades since his death. Like extraterrestrial muffins or broken-down Soviet satellites returning to Earth, Monet's haystacks have fallen into every corner of the city. And just what do they do for fun?

At the risk of appearing to stretch the Magritte influence to the breaking point, the formal aspects of *Haystacks, Paris, Night* bear a striking resemblance to the Surrealist master's 1928 *Man with a Newspaper*, a somewhat melancholy rumination on mortality. Likewise, here Monet's haystacks continue to thrive on walls all over the world, while these life-loving Parisians have been, by now, a long time dead. As has Claude Monet.

Haystacks, Paris, Night

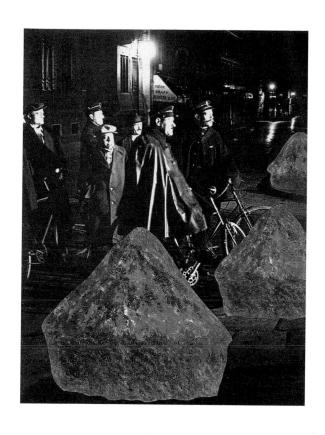
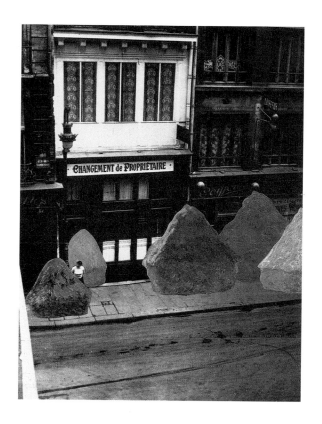
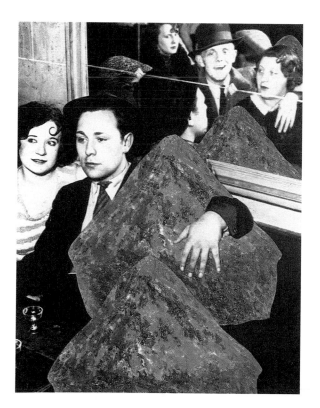
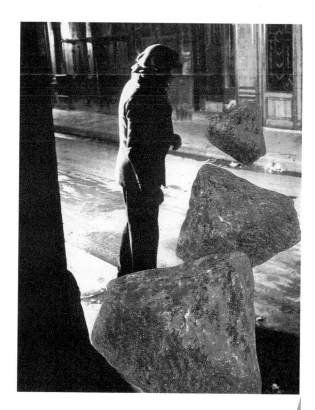

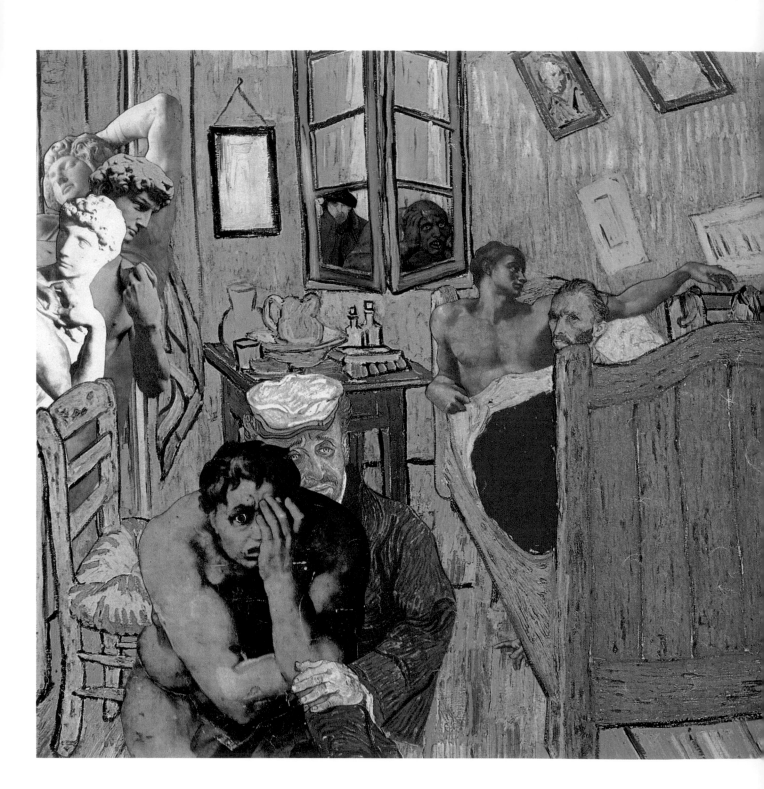

rude awakening at arles

The life and legacy of Vincent van Gogh (1853–1890) presents us all with a sad, gigantic, and obvious irony, one that Kite describes as: "He could barely sell a painting when he was alive, and now he's declared a genius. A painting of his will take in $54 million at auction, but he barely earned 54 bucks in his lifetime. None of that $54 million goes back to van Gogh."

Perhaps the realization of that chasm between his genius and his impoverishment struck van Gogh every morning he woke up in his tiny tilted room in Arles. It sure must have dawned on Paul Gauguin (1848–1903), who is staring in the window and with whom van Gogh had a love-hate and some have speculated a physical relationship. van Gogh's own self-portrait is suspended over his bed, while other images have been flown in from the ceiling of the Sistine Chapel in Rome. The contrast between the Sistine's architectural wonders and the humble hovel in Arles is as obvious as the irony in van Gogh's needlessly tormented life.

tsunami, pont neuf

Kite spent two years in Japan, teaching English and in turn learning the Japanese language and gaining an abiding appreciation for Asian culture. Immersing himself in the utter newness of all things Japanese, he discovered that they have some interesting ideas about possible uses of mayonnaise and that, not unconnected, "Freudian psychology just doesn't work in Japan." More pertinently, he gained firsthand knowledge of ancient and modern Japanese art and discovered, secondhand, the profound influence it had had on French Impressionism (see the bridge in *Monet's Dogs*). Kite has pursued this theme of cultural cross-pollination in a number of his collages, but in *Tsunami, Pont Neuf*, he is focusing specifically on the work of Pierre Auguste Renoir (1841–1919), who borrowed a number of elements from Japanese folk art. The tsunami, a prodigious tidal wave peculiar to the Pacific Rim, has been incorporated into the art, mythology, and culture of seismically active Japan. This one has washed ashore at Pont Neuf (Bridge # 9), the setting of many placid Renoir renderings of Parisians at leisure. One of Kite's recurring motifs—an enormous butt entering from above—is included here, too.

Tsunami, Pont Neuf

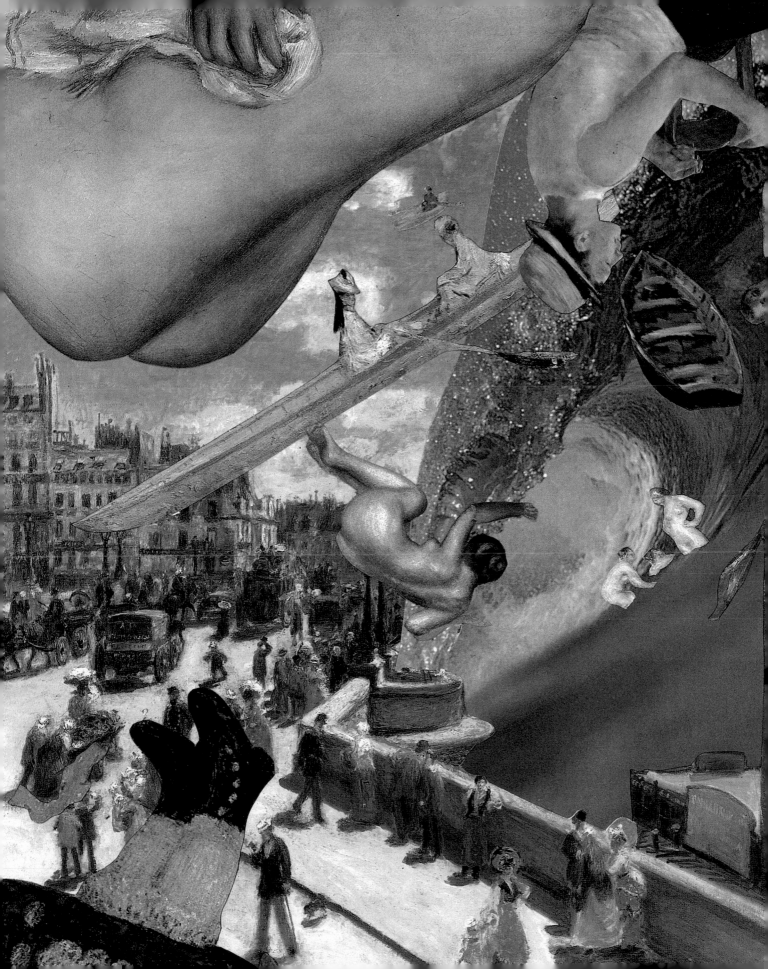

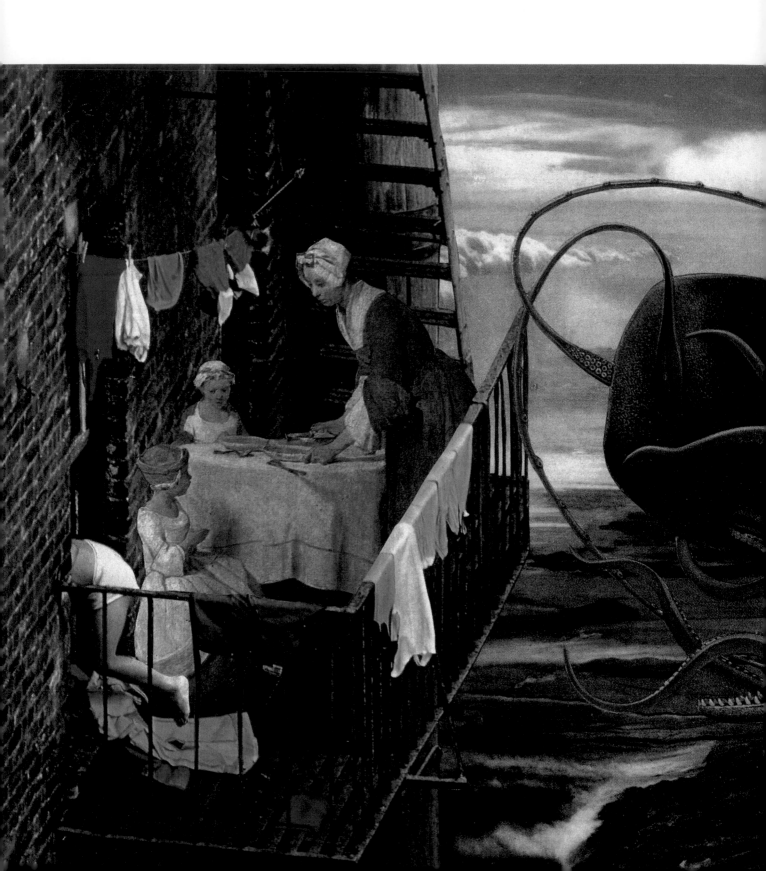

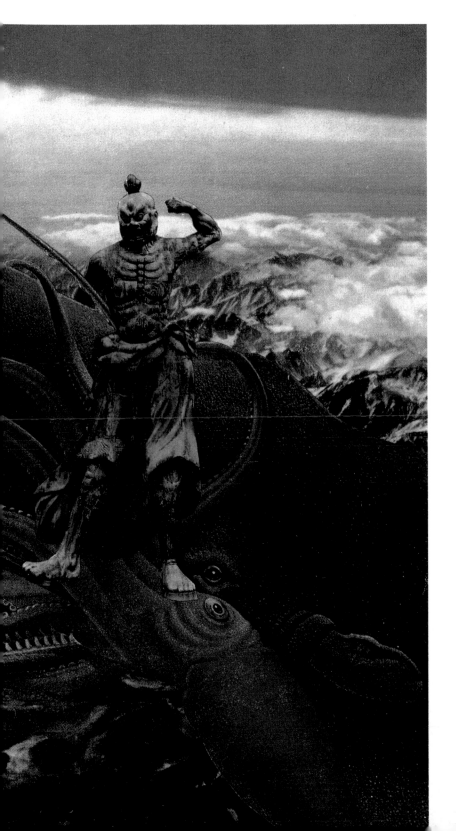

grace before sushi

The Far East meets the Lower East Side in *Grace Before Sushi*, another surrealistic homage to the time the artist spent in Japan. Like a stone surfer, a temple-guarding Japanese statue rides atop an impressively intertwined squid and whale that is stationed very much like the tidal wave in *Tsunami, Pont Neuf*. Catering is by Jean-Baptiste Chardin (1699-1779), who depicted a number of scenes from French middle class life with unaffected simplicity. Chances are he never saw a whale, certainly not one arriving from over the Himalayas.

koan A koan is a Zen Buddhist riddle that has no correct answer, so to speak, but is instead intended to clear the mind of its flab. "What is the sound of one hand clapping?" is the most oft-cited koan. Perhaps after you've pondered that one to your satisfaction, you might try the one Kite has posed visually in this collage. What is the sound of one Sumo wrestler stomping on Giotto's angels? Or, if no one else is in the Japanese meditation garden to hear them, do these same squashed angels make any sound at all?

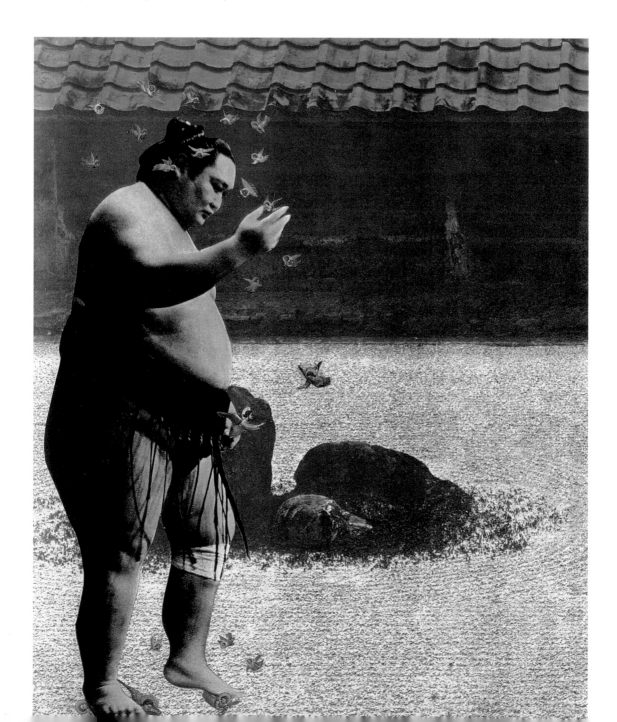

the**sistine**series

Kite is not a spiteful man, but his "Sistine" series is as close as he has come to exacting artistic revenge. When in Rome in 1970, he did as the natives did, sporting ragged jeans, T-shirts, and long hair and hanging around the fountains listening to bad versions of Bob Dylan songs. Among his most pressing concerns on that trip was to visit the Vatican's Sistine Chapel. He, of course, wanted to gaze in wonder at the ceiling paintings of Michelangelo, but was instead detained at the door by unsmiling Vatican minions, who didn't appreciate his looks. He was forbidden to enter the chapel. Instead of going back to his hotel to change clothes, Kite left Rome.

Since that time, he has returned to the Sistine Chapel a number of times, but only via his Aberrant Art studio. "You might say I have a personal relationship with the Sistine Chapel," explained Kite recently, still sporting jeans, T-shirts, and long hair. Among the results of that relationship are the following six images.

the fall
of man

Juggling the same figures in all of these images, Kite reimagines the Sistine Chapel as an ongoing, ever-changing drama, with God, Adam, Eve, the Roman slave, and one of the Doomed taking the different parts. In this dramatic crime scene, a piece of the ceiling's Creation story (Adam, taking a bow) has fallen onto the frozen tourist spectators. The figure at the bottom left seems to be pondering the lawsuits to follow. God is shoving his way past the phalanx of cops, shouting, "Hey, hey, I know that guy... I, er, created him, officers."

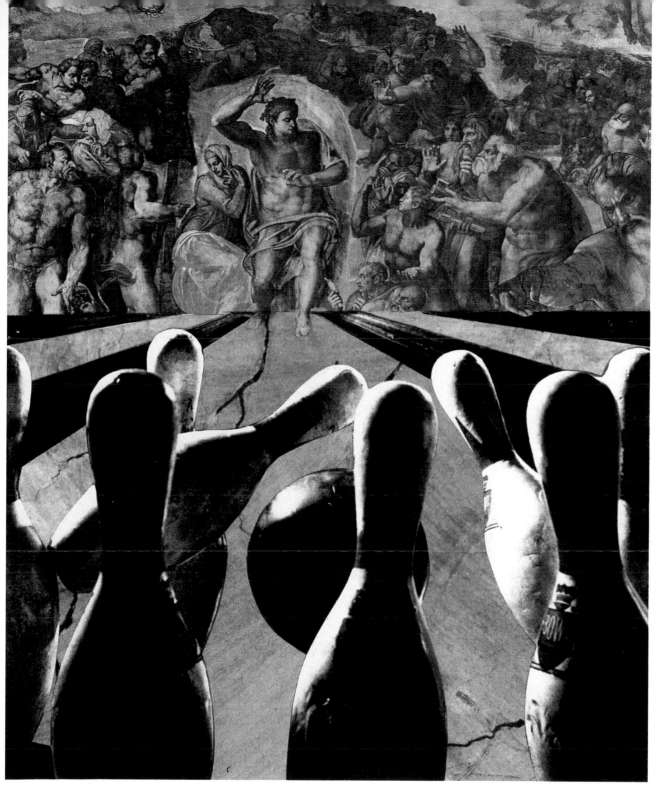

the sistine bowl-off

In *The Sistine Bowl-Off*, Jesus wows the other members of his Sistine fresco with his prowess on the alley. His dad, though, points out that "Yea, though ye may walketh upon water, thou hast steppeth o'er the line of fouls."

the sistine laundry

Unlike the others in this series, which are direct laser prints of a pasted-up assemblage, *The Sistine Laundry* is a hand-painted photograph of a paste-up. The Sistine People—"like the Village People," explains the artist, "only they're not yet into singing"—have opened a laundromat on the side, presumably to make up for the loss of revenue from the long-haired blue-jeaned art-lovers who've been turned away at the door. Alas, they've run into mechanical difficulties when the dryers go on the fritz, or blink. Note the hand of God extending a socket wrench toward the hand of Man (starring Adam), and the hand of the Doomed is extended to his brow in frustration. The nude in the lower right, courtesy of Gustave Courbet (1819–1877), would very much like her clothing back from the proprietors.

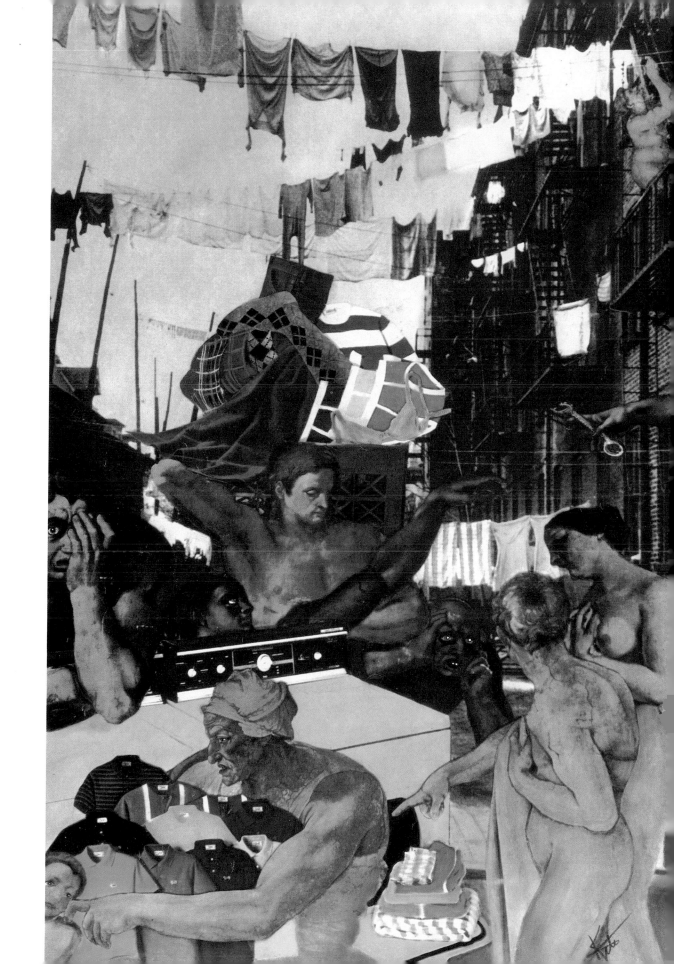

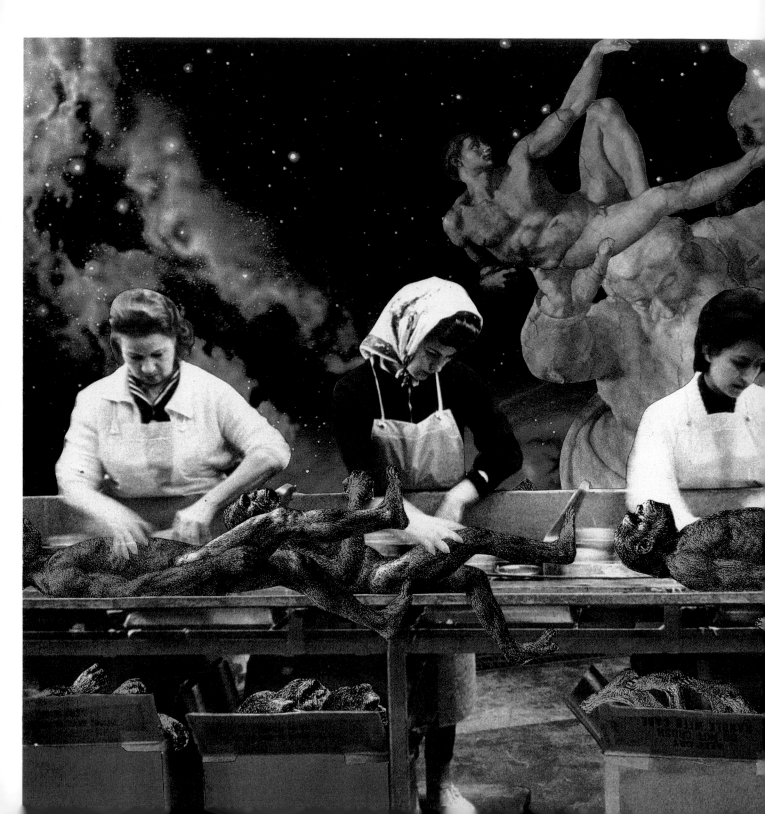

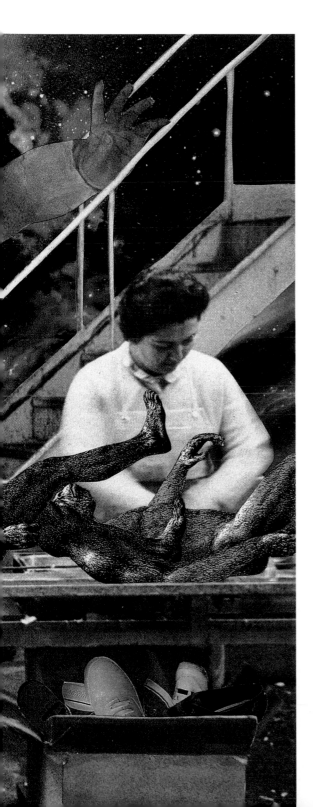

quality control

"Oops," exclaims Michelangelo's God, "How did that perfectly formed Homo sapiens get on the evolutionary assembly line? It's way way too soon . . . excuse me ladies, I'll take that. . . ."

The above is the scenario Kite had in mind when he constructed the evocative *Quality Control*, but he allows how the image is open to numerous readings. "People have other interpretations for this image and I would not want to interfere," he says. "Already I've said too much."

gotta dance With a little help from his friends at National Geographic and MGM, the Sistine's Godhead is able to assert his inner Fred Astaire. And why shouldn't God be allowed a moment to celebrate his remarkable accomplishments?

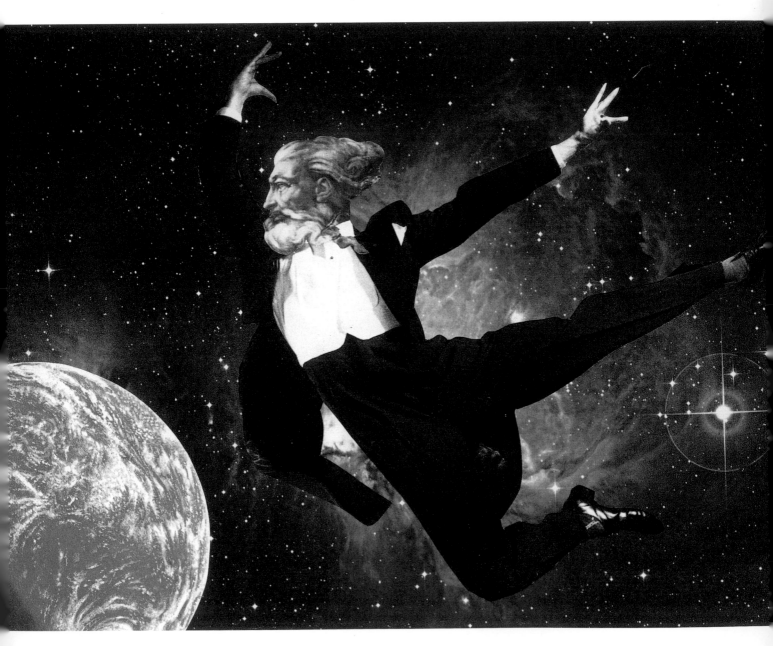

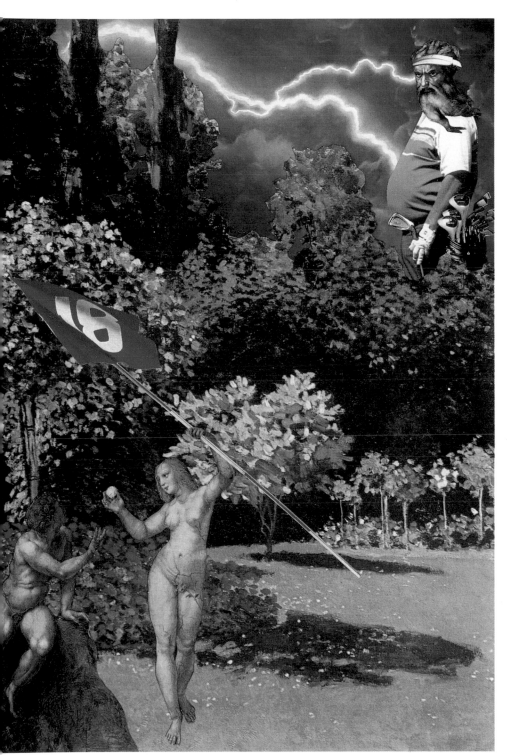

original sin

Captain Beefheart (aka Don Van Vliet) once referred to Earth as "God's golf ball," and Barry Kite (aka Captain X-Acto) has put the ball in play in *Original Sin*. Not only is it a tough lie for the Sistine's Big Guy, but his original sinners, Adam and Eve—as portrayed by Raphael (1483–1520)—have moved his ball, necessitating a penalty of at least one stroke. The real question here is how much longer will it be before Claude Monet sicks his dogs on the whole crew? (See *Monet's Dogs* on page 24.)

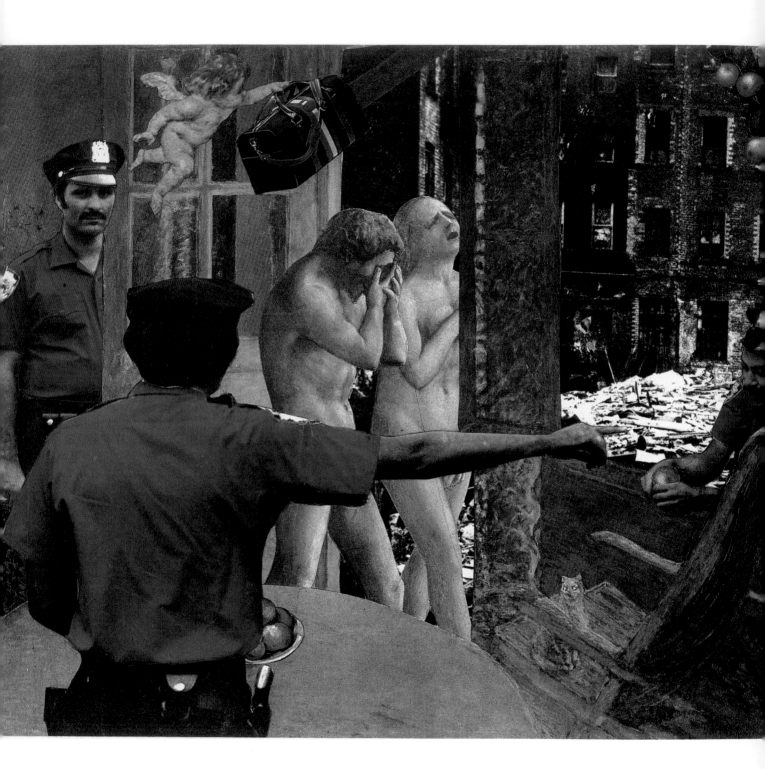

Adam and Eve have been evicted from the Garden of Eden for behavior unbecoming an unmarried couple in an age of family values. An angelic valet assists them with their overnight bag, while a cop decides whether one of Cezanne's apples is edible. The world into which Adam and Eve are being relocated is the Garden of Eden in reverse, or, Europe during World War II, though it could just as easily be Chechnya or Sarajevo. This version of Adam and Eve was painted by the great but short-lived Masaccio (1401–1428), a pre-Raphaelite in every sense.

the eviction

The Eviction

another
tough
break
for
the
jewish
team

As a subject for painters before the Enlightenment, the story of the Crucifixion was the equivalent of Everest for mountain climbers, Rachmaninoff's 3rd Concerto for pianists, and the long version of "In A Gadda Da Vida" for rock drummers. The number of depictions of this event surely rivals the number of angels that can fit on the head of a pin or cows that jumped over the moon. With this work, Kite is standing as firm as Dan Quayle on his vow to undermine idolatry.

"As advanced as we are culturally, some people still draw lines," he explained. "That's something I won't allow. I stop at nothing."

Here, in recalling the scenes of the Descent from the Cross, the Pieta, and the Entombment, a number of beatific Christs are scattered throughout the infield of a college track event. Contrary to numerous complaints from some viewers, Christ is not being pierced by an errant javelin toss; he has simply been less than successful at the pole vault. Likewise, this is not the 1936 Olympics, which would have added a blatantly political element to the collage that Kite generally eschews in deference to more open-ended interpretations. After a lengthy explanation of one of his works, Kite is fond of saying, "Or maybe you see something else."

As for the title of this collage, he says, "I'm a Jew, so this is okay."

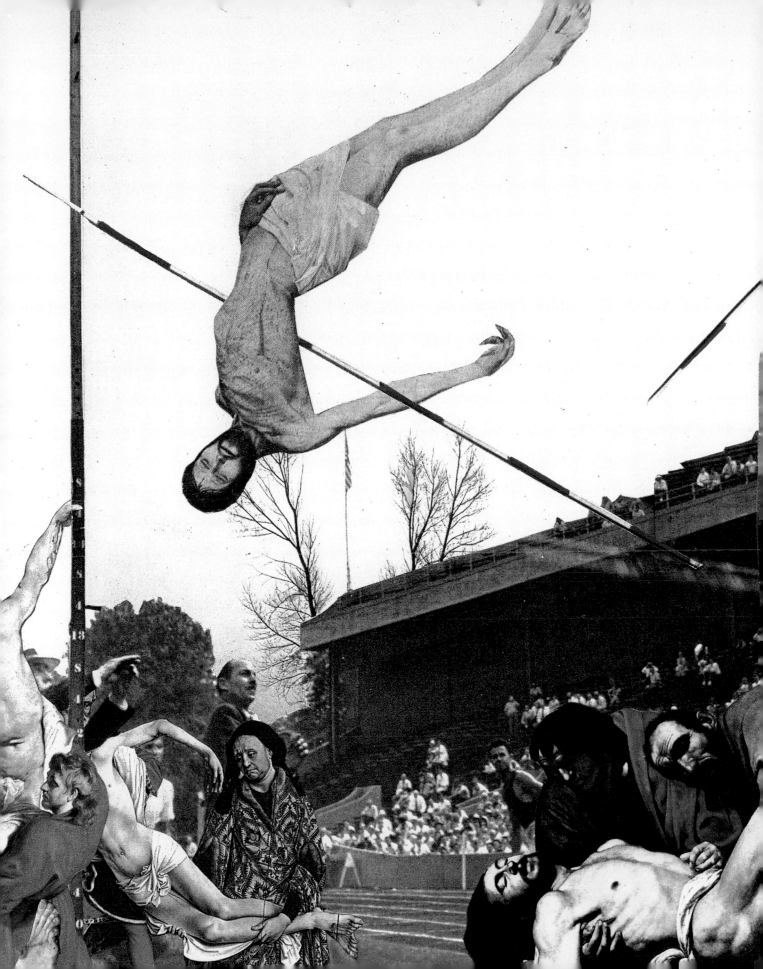

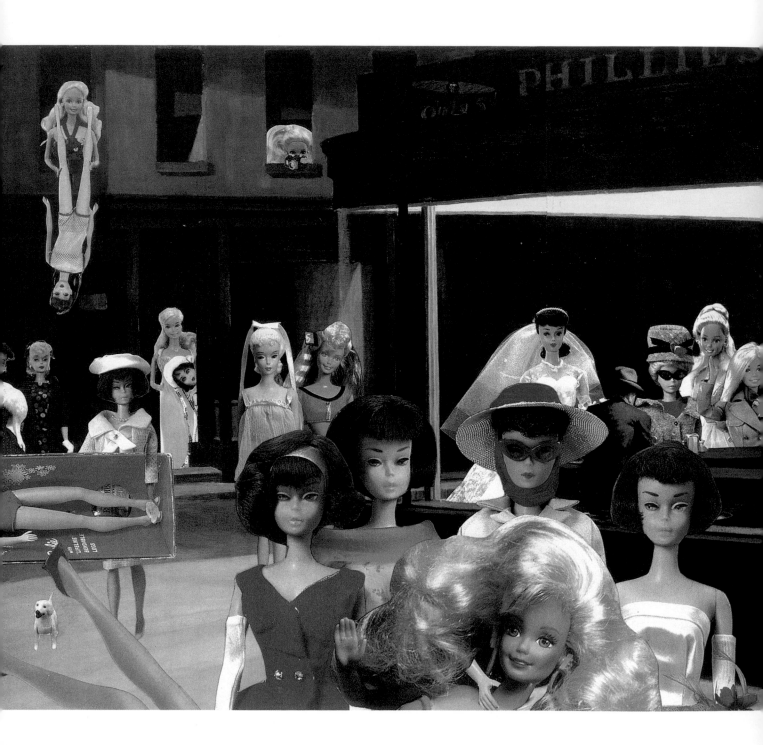

when will it end?

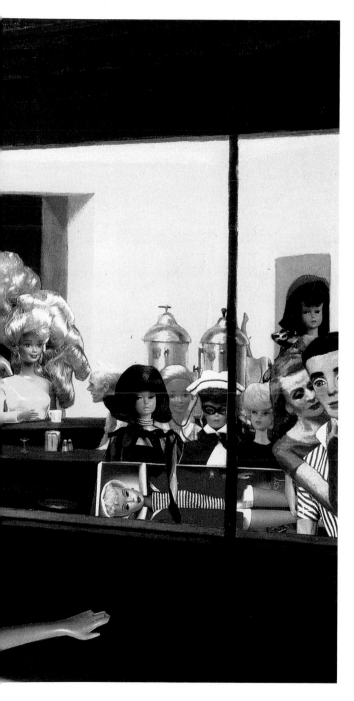

Kite has always been fascinated by the paintings of Edward Hopper (1882–1967). Long before he turned his hand to collage, Hopper's *Bicycle Racer* was the only print Kite ever bought at a flea market that he did not cut up. He is particularly smitten with Hopper's cafe scenes, where no one seems to be looking at or relating to anyone else in the painting. Hopper's moody tableau engendered in Kite a different sort of realization from the joyful epiphany he'd had at the hands of René Magritte's *The Treason of Images*. "Hopper's work was so somber it made me realize, long before I met Magritte, that art was not necessarily a happy thing. Or that it was intended to match the draperies."

In *When Will It End?*, Kite has expanded on the existential ruminations of Hopper's most reproduced image, *Nighthawks*, by adding "real" mannequins to the emotional ones created by the painter. The new nighthawks are Barbie dolls, which have now replaced the bloated drug-addled Elvis in the pantheon of ageless pop deities. Sight gags abound—a plastic dog biting a plastic arm, a peeping Barbie in an upstairs window, Hopper's dour dame playing kootchie koo with Ken—but other things are at work, too. See, for example, if you can find the fully intended parallels in *When Will It End?* to the musical *West Side Story*. (Think brunettes instead of Jets, blondes instead of Sharks).

For extra credit, find the parallels with the Elizabethan tale upon which *West Side Story* was based.

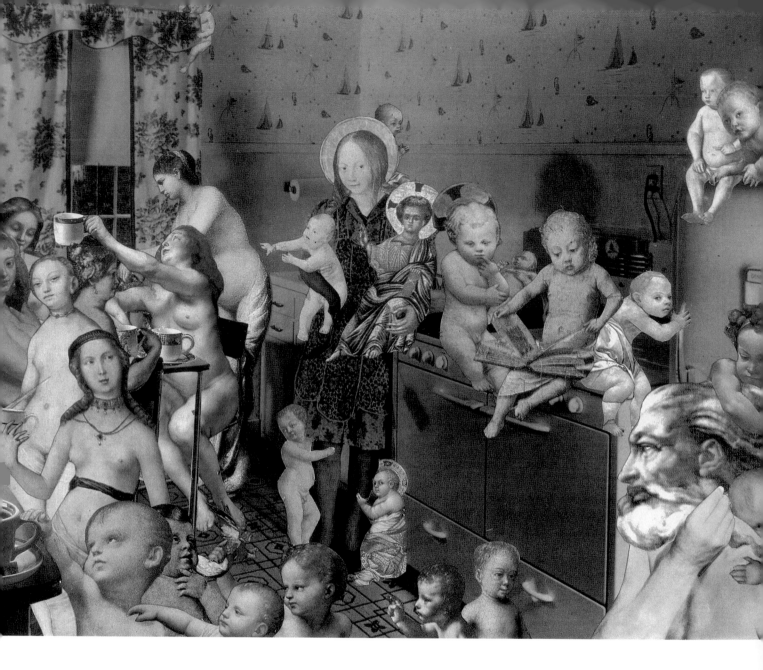

madonna of the unexamined life

Welcome to biblical day care. A room full of Christ children is being babysat by Venus, Eve, and Lucretia Borgia. God (lower-right corner) is trying hard not to be judgmental, but clearly some family planning is in order.

the hindenburgers

Two celebrated photographs ignite this collage, one an artful landscape shot of French burghers enjoying a picnic in the country, and the other a documentary news flash of the Hindenburg explosion in Lakehurst, New Jersey, on May 6, 1937. The picnickers are courtesy of André Kertesz, and the exploding blimp is courtesy of the Associated Press. The flaming skydivers are the work of God knows who. The Hindenburgers could be the people viewing, the people burning, or the food in the picnic baskets. Call this one a commentary on the peculiarly modern desire to witness catastrophe from a safe but appreciative distance. Perhaps this condition began at the First Battle of Bull Run in 1861, when the good folks of Washington, D.C.—hoping for a quick and entertaining end to the schism between the States—took picnic baskets to the Virginia countryside, only to be splattered by the blood and guts of the ensuing carnage. Hey, pass the ketchup, please...

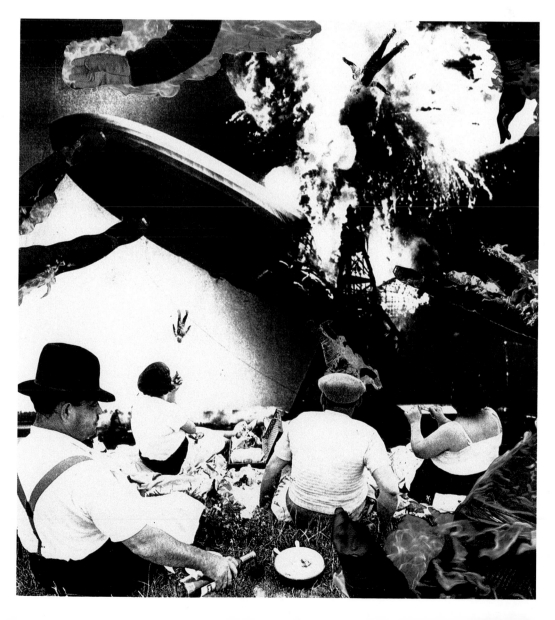

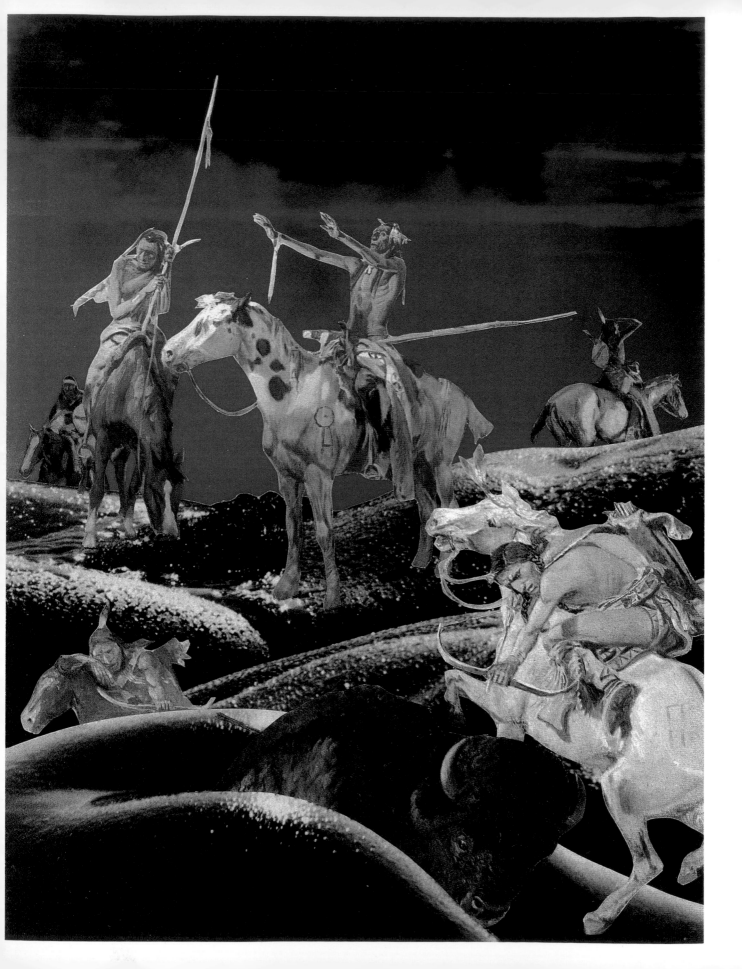

An illustrator named Frederic Remington (1861-1909)—Ronald Reagan's favorite artist—turned the cowboy, the Indian, and other "Wild West" characters into romantic figures that bordered on Greek gods and noble savages. His intentions were good enough, not unlike Edward Curtis's (*see Visionary*, page 19), but the resultant images became a benign sort of cultural cliché, softened Hallmark *the hunt* versions of real life juxtaposed against huge skies and hermetically sealed in an ideal, changeless world. Remington, in fact, foresaw—and bitterly bemoaned—the demise of the cowboys and Indians, like the ones borrowed for *The Hunt*. Another technique that began as unique and quickly became a visual cliché is the use of black-and-white nudes to depict a quasi-surrealistic landscape.

"I thought I'd let the Indians have a chance to explore them," says Kite, whose *Hunt* is intended to tweak a viewer's perspective. "The ground is not necessarily a ground, and the sky might not be the sky. It could be a pool of festering chemicals. I can only manipulate within the confines of a two-dimensional world."

The Hunt

flea market of the gods

This is Kite's all-time bestseller in the greeting card and print formats, and it has become a popular poster image in England, as well as the cover art for a CD by a San Francisco rock band called Smitten. Perhaps the success of *Flea Market of the Gods* reverberates from the personal connection it has with the artist. The people in it are Europeans rummaging among a flea market for bare essentials, still living hand to mouth in the year following the end of World War II.

"Not only does this image reflect my own hand-to-mouth existence during my time in Europe, and my experience as a vendor at flea markets," says Kite, "but the image of the people was taken from a magazine issued the month and year of my birthday. I feel I can do no wrong with any image taken from a magazine with that astrological connection."

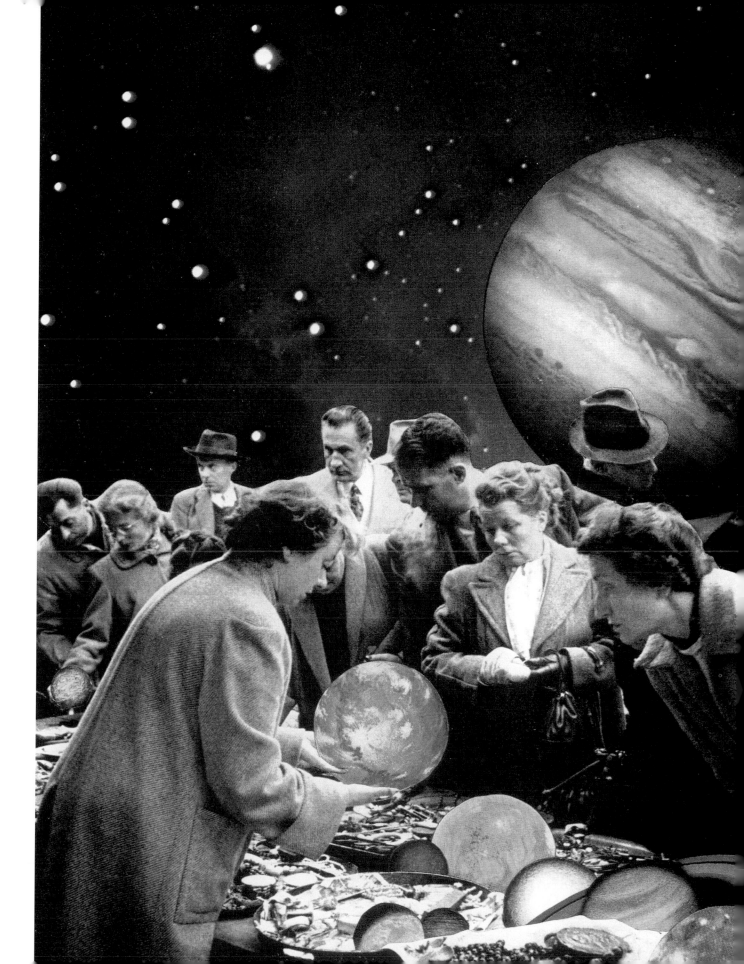

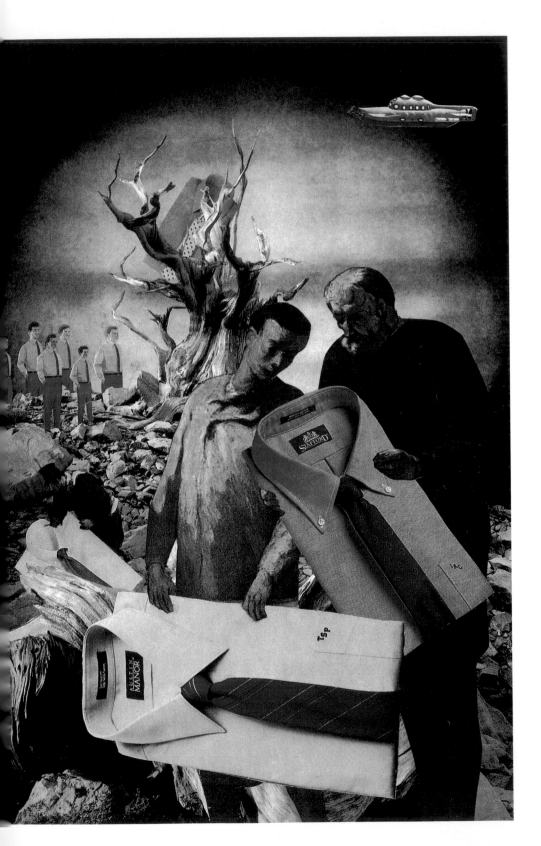

the mysterious dress shirts of jupiter

the affectionate bath towels from neptune

These two images from Kite's unofficial "Enigmas of the Universe" series remind us that we are not alone. One can only hope that extraterrestrial visitors are as friendly and considerate as the artist has depicted them here. God seems to be controlling the flight of the bath towels from behind the shower console, while the planet Jupiter looms behind the Daumier figures who are studying the dress shirts. If this is a moon of Jupiter, who are these clothing salesmen in the distance? An additional mystery to keep a viewer up late at night is provided by the monograms on the dress shirt pockets. TSP? Thomas Pynchon? JAC? Jimmy Carter?

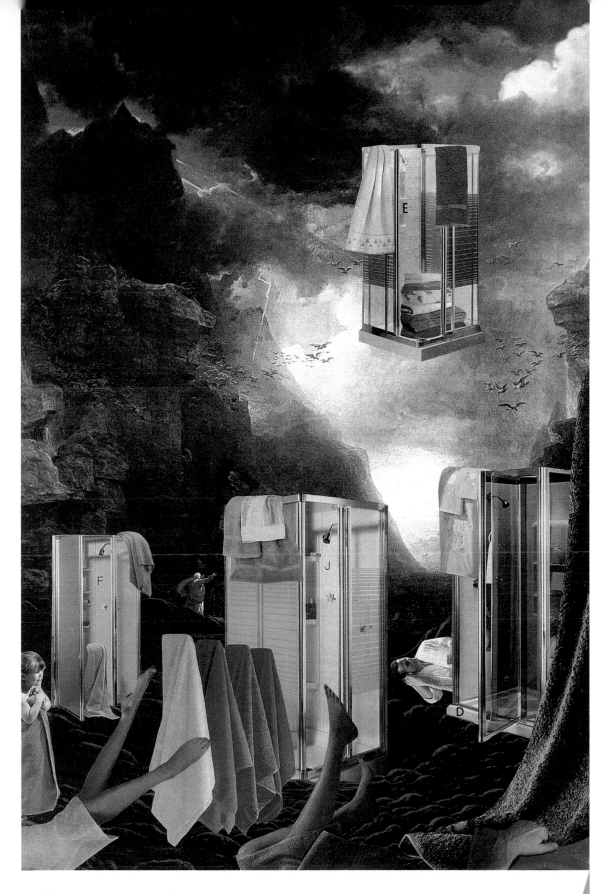

The Affectionate Bath Towels from Neptune

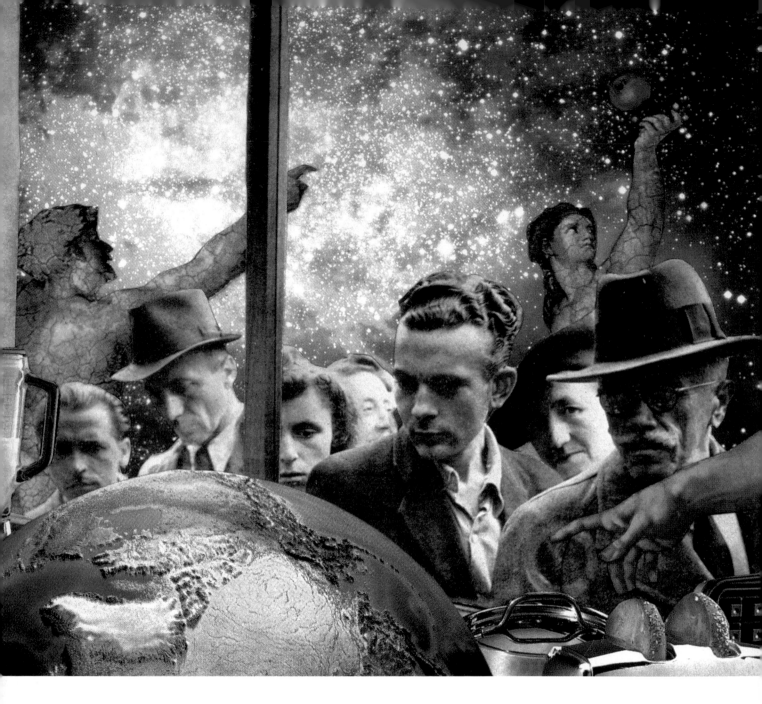

the "big sale" theory

The same juxtaposition of the cosmic vs. the mundane is used with equally strong effect in *The "Big Sale" Theory*, a convincing rebuttal to the Big Bang Theory on the origins of the universe. Instead of bare essentials, though, shoppers are gazing at luxury consumer items on a luridly enticing display in a shop window. Once again, the Sistine's God makes a cameo. He is making his selection while Adam and Eve amuse themselves outside.

monday

Pierre Bonnard (1867–1947) was known for his intimate depictions of quiet domestic scenes. Surely, he occasionally gazed out the window to see what he might be missing. On this Monday, with the unknown quantities of the coming week lurking around the corner, his paranoia seems to have taken a more tangible form.

"This is what I consider an audio piece," says Kite. "If you hold it up to your ear, you can actually hear the accordion, the thunder, and the sound of cows falling on dancers. Try it."

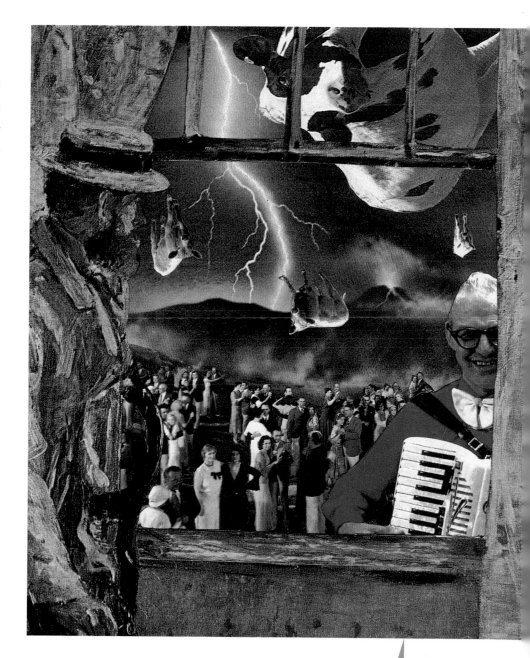

the gene pool

Ever since the days of Goya (1746–1828)—whose happy women comprise the safety net for *The Gene Pool*—the genetic pickings seem to have gotten slimmer. As the artist explains, "This image combines mitosis, farm animals, and raw sex." See if you can find the raw sex.

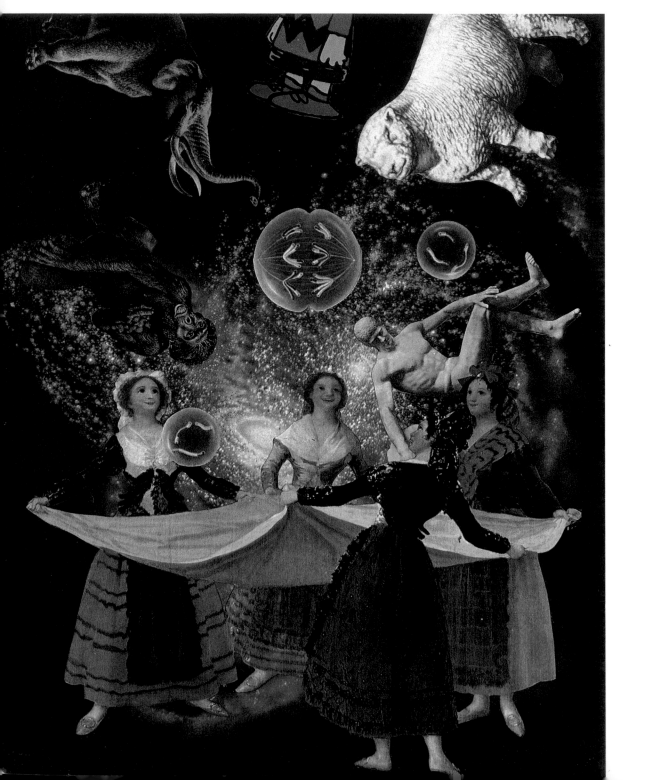

christina removed for observation

Kite's artwork has undergone a subtle refinement over the years, evident in a later image like *Christina Removed for Observation*. Only two pieces are used in this collage, and only one is taken from a work of art. That image is obvious enough, *Christina's World* by Andrew Wyeth, the visual equivalent of a pop celebrity and, according to the *New York Times*, "the most famous work by an American painter since World War II." This one simple juxtaposition completely reinterprets Wyeth's pastoral vision and offers pointed commentary on the deification of works of art. Some concerned neighbor has obviously alerted the authorities to Christine's protracted condition. And who's that artist scurrying away in the field?

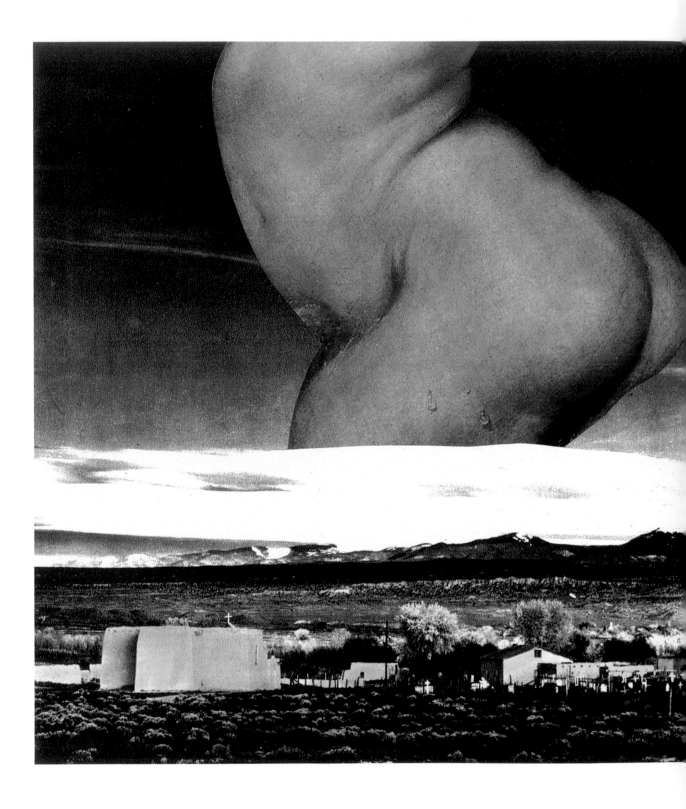

enormous butt, hernandez, new mexico

While the artist is clearly cracking a visual joke in *Enormous Butt*, the joke comes equipped with more than one punch line. The butts of the joke are not the artists whose work is appropriated here—Ansel Adams and Peter Paul Rubens—but the art industry that has turned them into commodities. Kite found a news story about how prints of the Ansel Adams photograph "Moonrise, Hernandez, New Mexico" were selling for tens of thousands of dollars apiece, and that hundreds of them had been made—some by Adams's assistants. He clipped the item from the paper and taped it to his refrigerator (where it still resides, now covered by the swelling coral reef of similarly inspiring notices). He then ran to his office studio and made *Enormous Butt* as his rebutt-al. Kite's creative bowels were similarly moved when he later read that an Alfred Stieglitz photograph of Georgia O'Keeffe's hands sold for $398,000.

"I'm acutely aware that there's an art business that has nothing to do with the artist and the reason for his or her doing the art," says Kite. "The visual joke is not on the artist but on the fact that these works are valued so much by someone else. If you can get 400 grand for a shot of someone's hands, then it becomes ridiculous."

Also interesting is the reaction this sea nymph's derriere has engendered since it was elevated from a minor section of Rubens's *The Arrival of Marie de Medici at Marseilles* to a starring role.

This version of *Enormous Butt* has been hand-colored to, according to Kite, "make it more my own." It has also been commodified—and is selling briskly—as a mousepad.

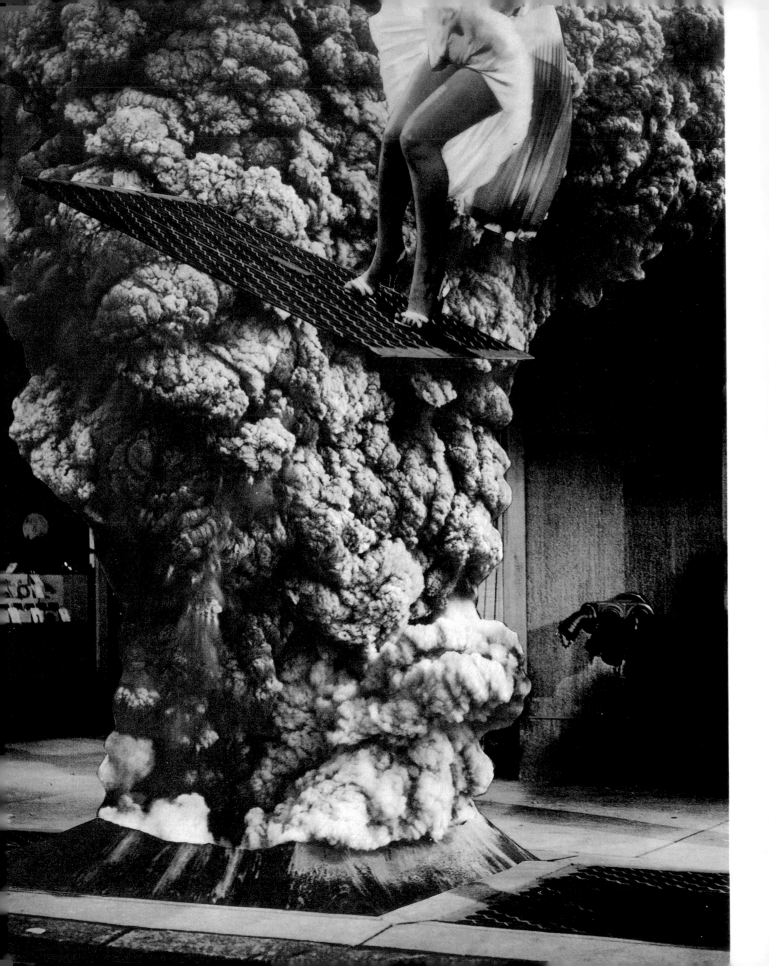

goodbye, norma jean!

Barry Kite knew he had crossed into new and uncharted territories when he sold hand-painted prints of *Goodbye, Norma Jean!* and *Sunday Afternoon, Looking for the Car* to a blind man at an art fair in St. Louis.

"His wife was with him," says Kite, "and she described for him what the image was . . . a field of Volkswagens, an Impressionist painting, and he says, 'Let's get it!' When they came back later to pick up the print, I showed them this one. I guess the man had gradually lost his eyesight over the years because he had remembered seeing the movie *The Seven Year Itch*. And his wife says, 'Well, there's Marilyn, and she's being blown up with a mushroom cloud under her skirt,' and the man just explodes with laughter and shouts, 'We have to get it!'"

While the anecdote is amusing, it also underscores the story element that is essential to Kite's collages, a direct outgrowth of his having come to visual art as a "word man." "If you can sell a work of art to someone who can't even see it, but who can appreciate a description of what is going on in it, and the desire for that object can be built up with only a few words . . . well, that's the key to what I try to do."

That's Mount St. Helen's, not a mushroom cloud, under Marilyn's skirt, making this an "all natural image." Or perhaps au natural.

Goodbye, Norma Jean!

birth of the blues

This striking image came to Kite while he was manning his booth at an art fair while the New Orleans Jazz Festival was in progress nearby. His booth was positioned in such a way that he was within earshot of three different stages, and the music from each stage hit him from three different angles. That clash of sounds, set inside a city that is the living embodiment of cultural diversity (and some would credit it as the birthplace of jazz, if not the blues), set off a chain reaction in Kite's mind.

"I wondered if I could get that same interaction of movement and sound into a work," he said, setting to work once he re-turned to his studio in Petaluma, California. To re-create the whirlwind he'd experienced in person, he chose three different time periods, three different musical styles, three different forms of movement, and three different forms of color. The black-and-white image is a photographed interior of a 1930s Southern juke joint. The leaping ice skater is an unnamed figure from a proto-pink-psychedelic color film advertisement of the late 1940s. And the lyre and lute players are from a painting by Dante Gabriel Rossetti (1828–1882), whose singular mission was to re-create pre-Raphael–era art. Out of this mix of color, styles, and movement springs *Birth of the Blues*, one of Kite's most successfully evocative images.

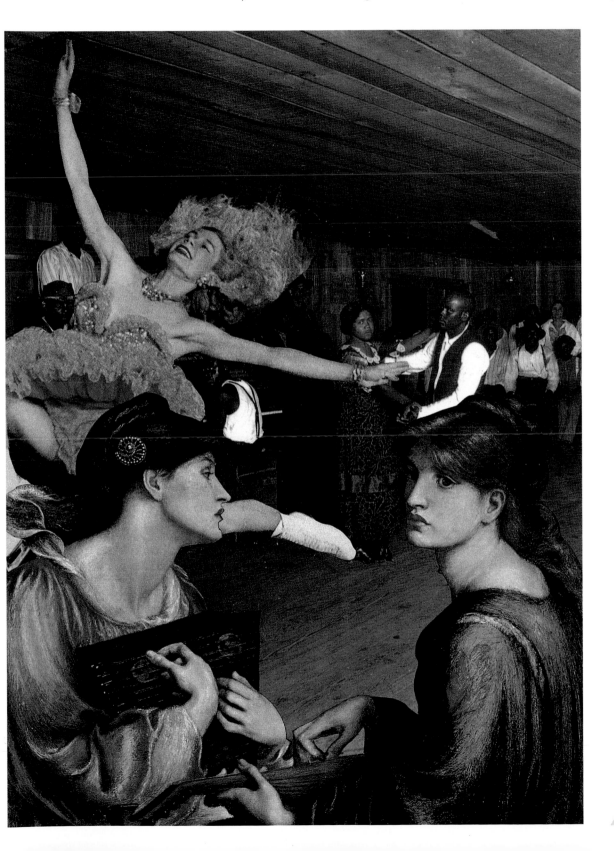

73

the**nude**series

The overuse, or reliance on, the nude is a temptation that all collage artists must eventually face, if they want to develop their talent.

"There's an evolution to making collages. First, you take *Playboys* and *Penthouses* and you toy around with those. If you stay with that, though, you evolve. Because of my greeting card line, I get people sending their collage works to me, in hopes that I'll publish them as cards. And I can see immediately what stage they're in. If they're in the *Playboy* stage, they need to get a little more refined."

When he was married, Kite was asked by his wife, "Why can't you make a collage without a nude in it?" So, he set out to meet her challenge in a very determined way and began avoiding the use of nudes completely. "Of course," he admits, "I got into corpses instead, so it wasn't much of an improvement." Still, the discipline was constructive, and he has moved away from the photorealism of stroke magazines to the classic nudes of Rubens, Courbet, and Botticelli as well as the abstract images of Picasso and de Kooning.

clumsy nude

Surely Marcel Duchamp (1887–1968), modern art's master of sublime irony, would enjoy Kite's take on his *Nude Descending a Staircase, No. 2.* When that painting was publicly unveiled at the Armory Show in 1913, it generated an avalanche of criticism and outrage, not unlike the reception accorded the Robert Mapplethorpe photographic exhibit in Cincinnati in more recent times. Soon after the Armory Show, Duchamp's geometrically tumbling forms became the target of endless parody from those Babbits, boobs, and reactionary roobs who were predisposed to debunk anything modern

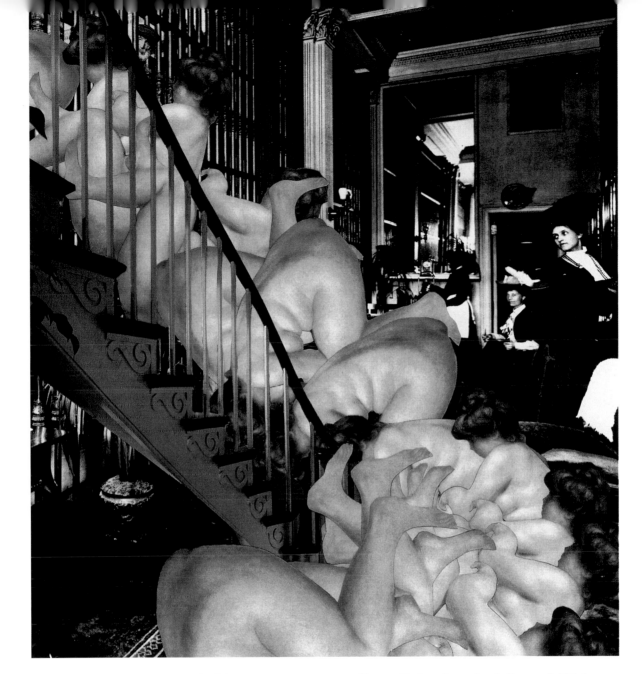

Clumsy Nude

or new or progressive—in art, or probably in anything else.

For *Clumsy Nude*, Kite clarified Duchamp's descending figure by using numerous variations on a plump and pink Renoir nude against the photographic backdrop of a 1890s hotel lobby. You can see Renoir himself poking his head out from the upstairs banister. Perhaps he and his naked model have had a falling out?

Clumsy Nude echoes back through Kite's personal history. The first piece of art he ever sold was called *Dog Descending a Staircase*. Even while he calls that "one of my high points as an artist," Kite allows that "I sold the piece for $325, but I spent a couple thousand to rent the gallery space." He got some dues-paying consolation when he sold *Clumsy Nude* to Bill Graham Presents, Inc., for a concert poster advertising the Bay Area appearance of Cake.

inner city nudes

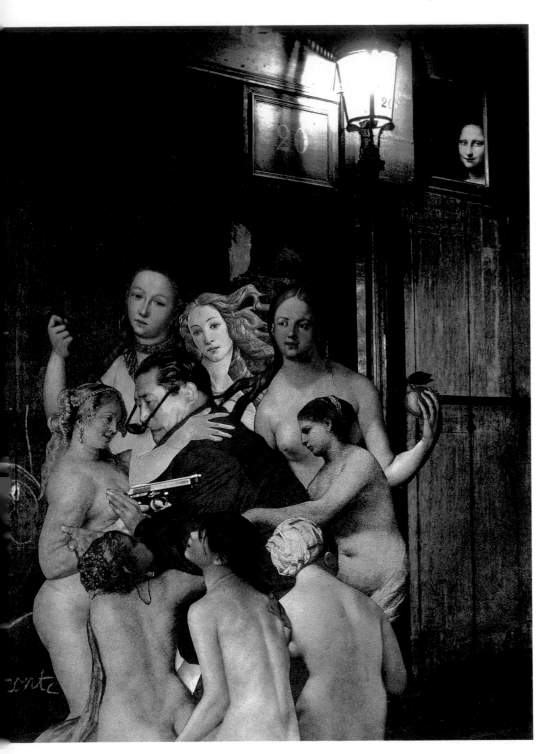

No city street in the world is safe from Kite's nudes. Not Paris, not Japan, not even the Garden of Eden. The central figure in *Inner City Nudes* is, in fact, Inejiro Asanuma, chairman of Japan's Socialist Party. In the Pulitzer Prize–winning photograph from which he is taken hostage, Asanuma has just been fatally stabbed by a fanatic ultra-rightist during a debate on October 12, 1960. The nude at the top left appears to be finishing him off, like one of Caesar's assassins, with the knifelike stem of her flower. The handgun is of American vintage, acquired by one of the nudes before the Brady Bill was passed. Mona Lisa seems resigned to urban violence, snugly locked up in her apartment.

As Kite says of *Inner City Nudes*: "It's a reflection on the state of our inner cities. In this allegory, the nudes represent naked women."

Or so he wishes.

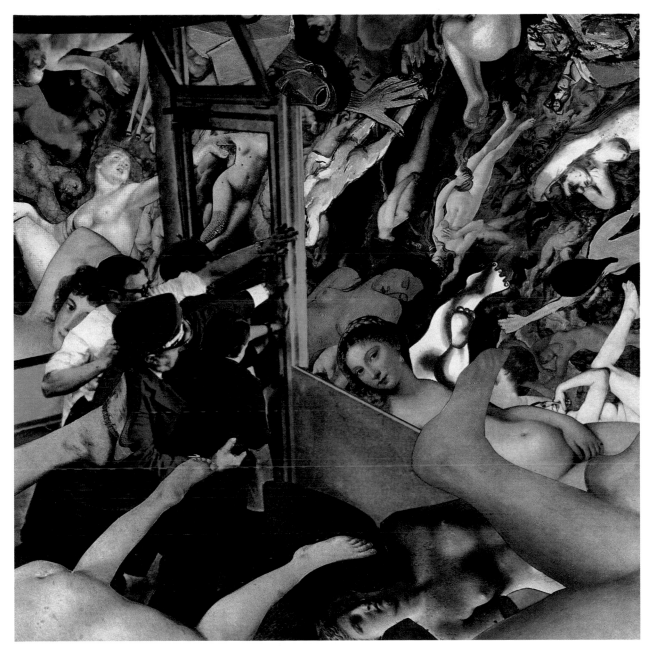

nudestorm

No nudes is good nudes to the employees of this German department store. It's raining cats and nudes outside, and they're having trouble holding the deluge back. Venus, for one, has managed to get inside, no doubt in search of her missing arm. Among the downpour are the morphologically challenging nudes of Pablo Picasso and Willem de Kooning.

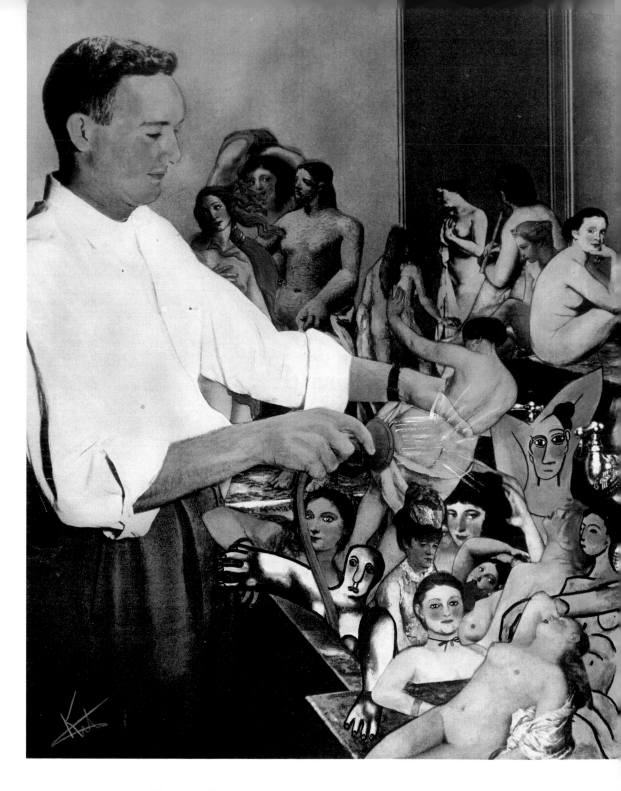

nude bathing

After the *Nudestorm*, these women need more than just a nice, relaxing bath. Whoa, Nelly, one of the bathers is reaching for the wrong nozzle. *Nude Bathing* is taken from a painted photograph of a paste-up. Kite is making a statement about personal hygiene, though most viewers prefer to play "Name-That-Nude."

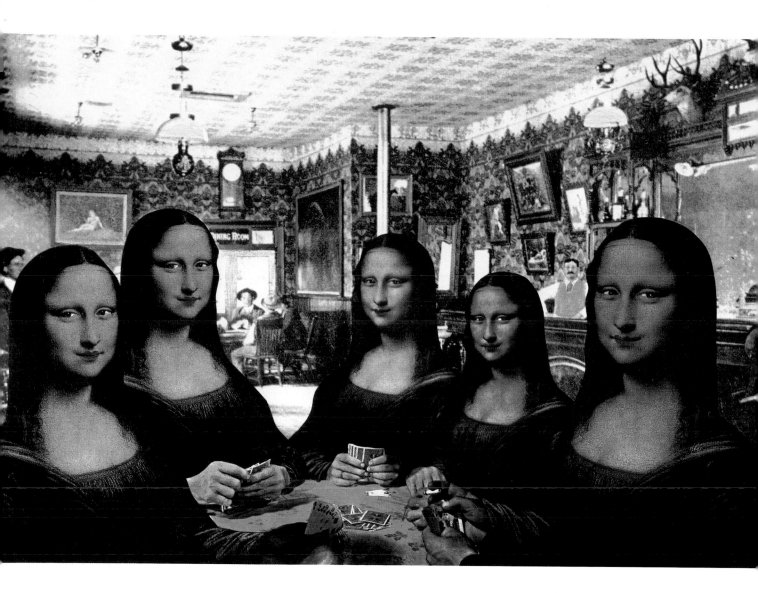

whose bet?

No matter where she is seated at the table, Mona Lisa plays a winning hand. While a slight manipulation of perspectives and sizes was required for *Whose Bet?*, so seamless and successful does it appear that Bill Graham Presents, Inc., used this image for a concert poster advertising a recent Fillmore appearance of Tom Petty and Taj Mahal.

damn! The background for this warm Yuletide image—the Houses of Parliament—is provided by Claude Monet, and the deer hunters are by Arthur F. Tait. The remainder of the piece, Santa et al., comes by way of Golden Books, which Kite considers a legitimate source of iconography.

"Before this got released as a greeting card, I was warned that Christmas was too sacred a holiday to support such imagery," says Kite. "Ho ho."

It is one of Aberrant Art's most successful Christmas images.

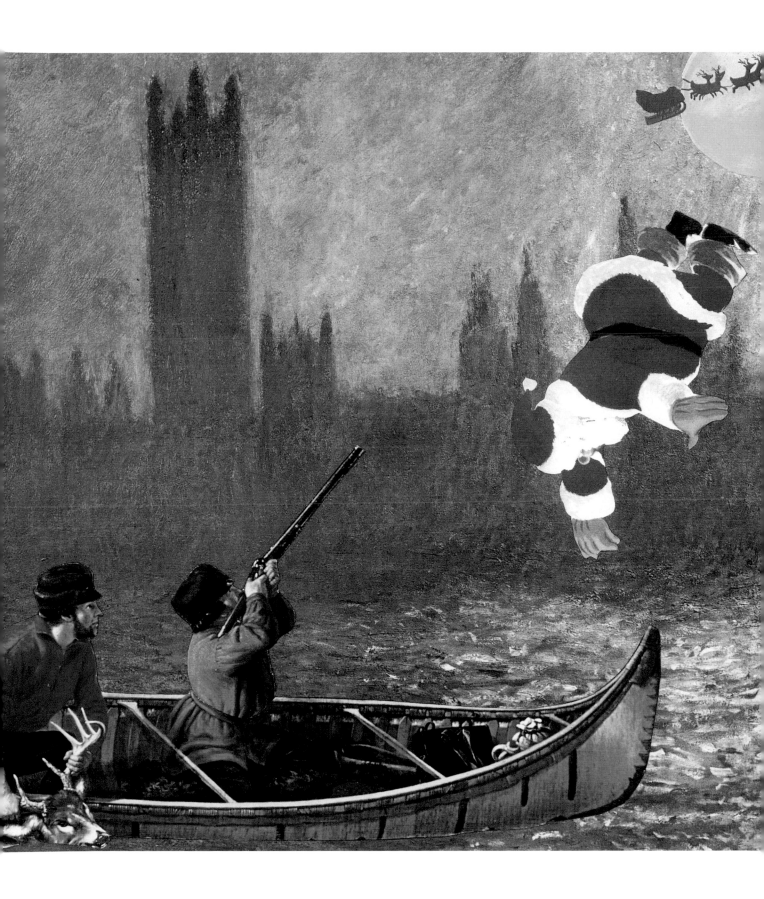

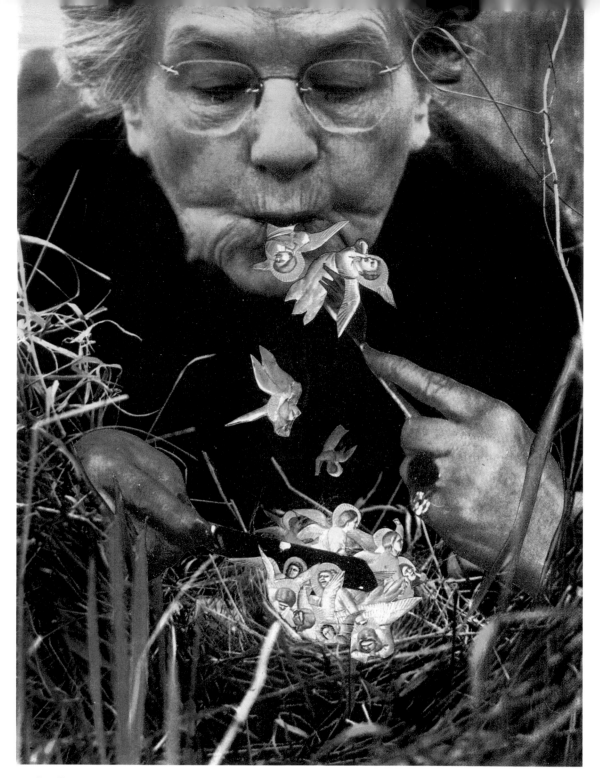

al fresco Originally conceived as a mural for an Italian restaurant or a bank, *al Fresco* makes the case for life as one gigantic food chain. The woman, the president of a bird-watcher's organization, was found in *LIFE* magazine. "Her granddaughter saw this piece at an art fair, but didn't sue," says a clearly relieved Kite. The angels are from a fresco by Giotto.

wings No mother could be happier than this—a big bowl of wings and lots of naked kids to put them on. Or slice them off of, if they have been naughty little cherubs. Kite was hoping this would work as a Mother's Day card.

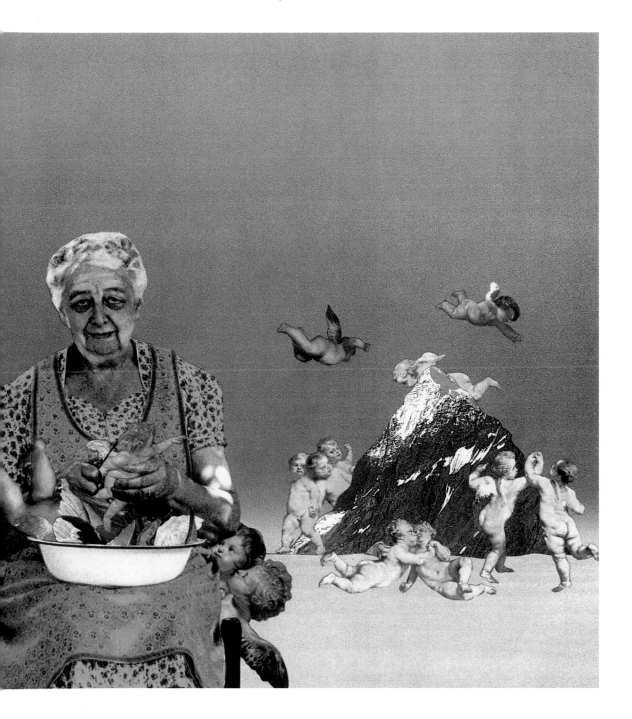

the**artist**series

Continuing his scrutiny of abstract art, Kite pays a housecall on the geometrically obsessed Piet Mondrian (1872–1944), with a letter of introduction from photographer André Kertesz. The contrast between Mondrian's cool, abstract formalism and "the nice juicy butt of a Renoir" is fully intended. Indeed, Mondrian finds himself in a compromising position and with his hands full of big brunette. Also helping to loosen his libido are nudes by Titian, da Vinci, El Greco, and Ingres.

"I felt it was time that Mondrian and Renoir got together," says Kite. "It would probably help both of them out."

Artist Being Compromised

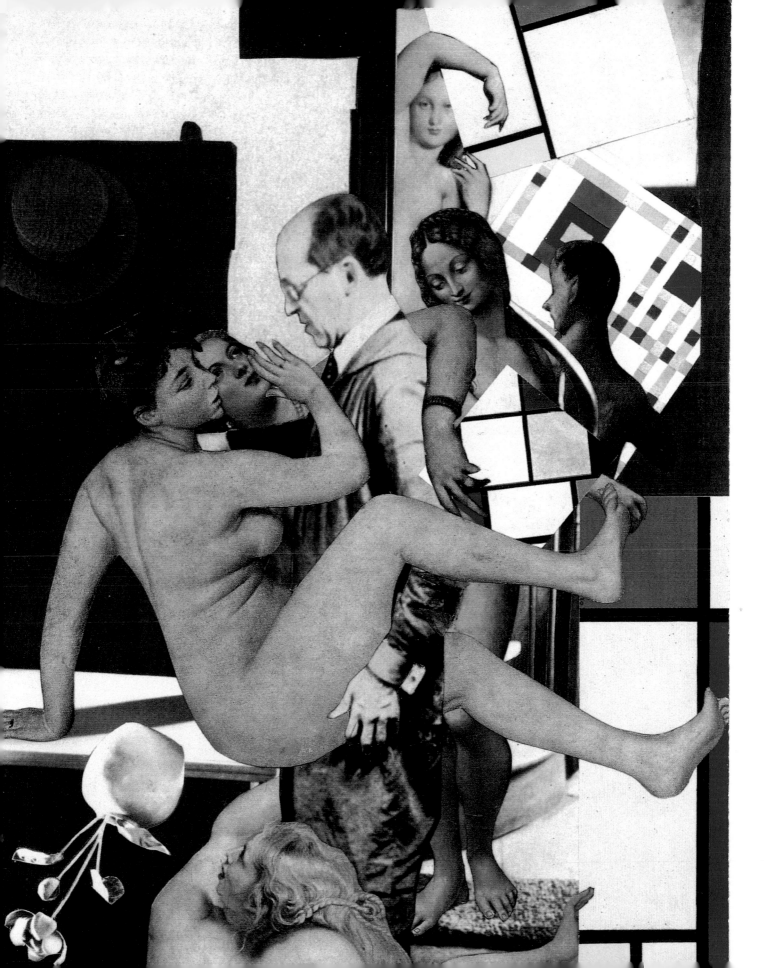

artist being detained

This arresting image finds Nicolas Poussin (1594–1665) being taken downtown for questioning, presumably in connection with reported disturbances in Edward Hopper's apartment building. It seems as if Poussin's *Rape of the Sabine* has gotten completely out of hand. These world-weary cops thought they'd seen it all, until they got this emergency call.

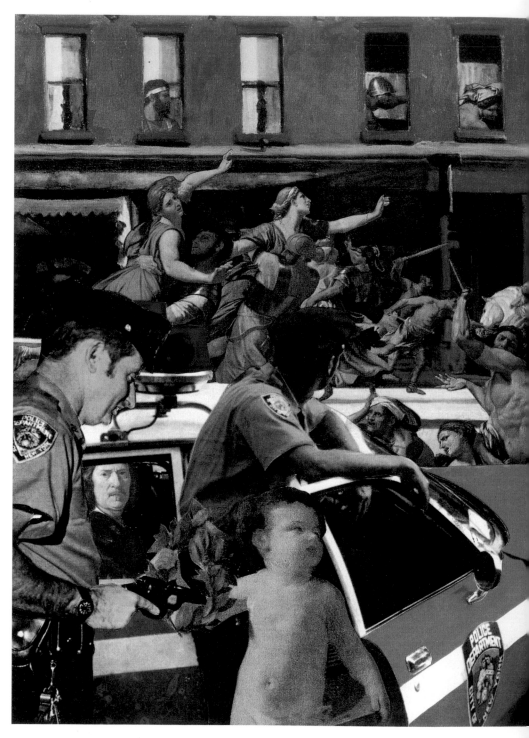

artist with rented car

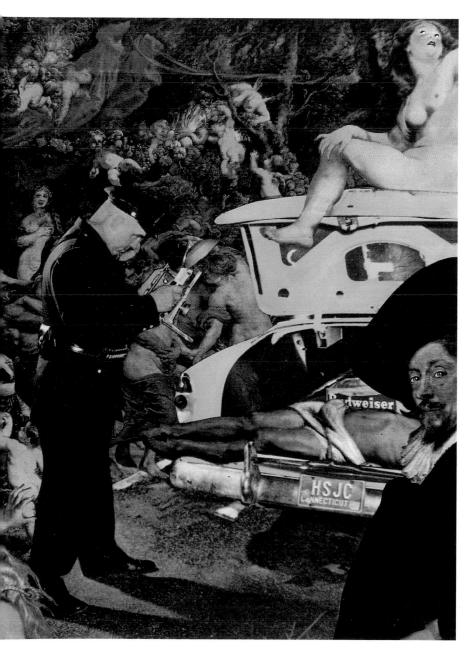

Peter Paul Rubens (1577–1640) enters from stage right. "Excuse me, officer," he politely inquires, "but is there some problem here? Oh, Jesus Christ, how did that body and those Budweisers get in my trunk?!" Rubens does know how that nude got on his roof. She's from his *The Rape of the Daughters of Leucippus*. All those other bodies are from an assortment of Rubens's other works, including another daughter of Leucippus in the bottom-left corner.

dysfunctional social drinking patterns and their effect on upper atmosphereric ozone depletion

This image and caption—inseparable, one from the other—were briefly considered for the cover and title of this book, respectively. Several things worked against them, however. First, it was feared that the book would be mistaken for an illustrated bartender's guide. Or, worse, a scientific abstract—and Kite is vehemently on the record as "reacting against abstract art in any form."

Nonetheless, this is among Kite's most completely imaginative images. The artist as sloth, molecules as M&Ms, society women as angels, and vice versa. . . . It's all enough to make any man collapse onto the floor.

"This image should cause people to think," says the artist, "but not unless they would otherwise do so, and certainly not while operating heavy machinery."

The 20th century has gone quite some distance to prove that war, not politics, makes strange bedfellows. The devastation of this World War II battlefield in the Soviet Union—which lost an entire generation to the carnage—could not be more complete. But, with a little Yankee ingenuity, and venture capital, even this scene can be turned into a challenging par 5. The shell-shocked caddies, like the recently unyoked Russians, will take any work they can get, though some of the other players are prone to falling down on the job. You might say they have had their share of bad lies. It's always the big lies that seem the most believable. Joe Goebbels said that. The bigger the object, the more respect it gets. Barry Kite said that.

avoiding the rough

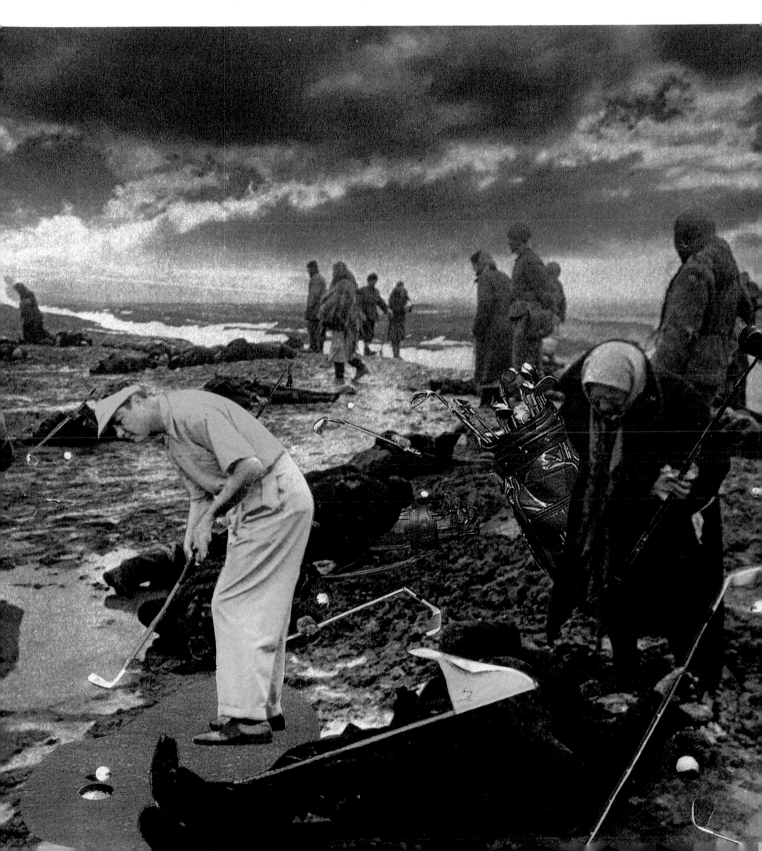

theroundpieces:

Among Barry Kite's most ambitious and powerful pieces
is a series of one-of-a-kind collages that he constructed on round
wooden table tops primarily between 1987 and 1989 (the three re-
produced here were completed in 1992). Each of these 52 mixed-
media works includes at least one piece of "found art"—a home-
made oil painting or photograph purchased at a flea market or
thrift shop. This element lends the work an added poignancy, by
incorporating some anonymous soul's personal history, begging
any number of questions, and echoing the lessons of Magritte in
Man with a Newspaper:

* Why didn't the owner keep the "found" piece of art?
* Was the memory too painful, or too easily forgotten?
* What ever happened to that budding artist who paint-
ed the piece?
* What ever happened to the subject depicted?

Encased in a circular shape, these works have an entirely
different effect on viewers' perspectives, requiring them to work
harder to enter these brave new worlds, these separate universes.
The round pieces are coated with a quarter-inch-thick polymer
resin. Large (36 inches in diameter) and extremely heavy, they
are difficult for Kite to tote around the country in his van. Thus,
only people fortunate enough to have visited the Aberrant Art
studio in Petaluma, California, have seen them. Included here
are just three of these remarkable and unique works. The cap-
tions are the verbatim comments of the artist.

relativity
(page 94)

"A young Einstein stands on the bank while famous nudes cavort in a pool. The sky is filled with nudes being carried away by flying crucified Jesuses. This piece epitomizes a repeated theme of mine: Beauty, Love, Sex being stolen away by institutionalism and convention while the Jewish genius (that would be me) stands on the shore. Or maybe you see something else?"

still life with psychoanalyst
(page 95)

"Pieces of modern art are dropped into bottomless chasms by beautiful nymphs under the gaze of a giant Buddha and images representing institutionalism and convention, while off to the left in a convertible sits Sigmund Freud, representing a Jewish genius (that would be . . . me).

under the bridge
(page 96)

"Beneath a black-and-white painting of the Golden Gate Bridge, a collection of Greek statues vies for modern art pieces falling from the sky accompanied by indistinct line drawings of human forms, crashing on the rocks below, witnessed by a group of Aztec statues threatening a passerby, while a pretty young lady sits atop a promontory looking wistfully skyward in search of a Jewish genius, who unfortunately couldn't make it this time. . . . Of course, there are many interpretations."

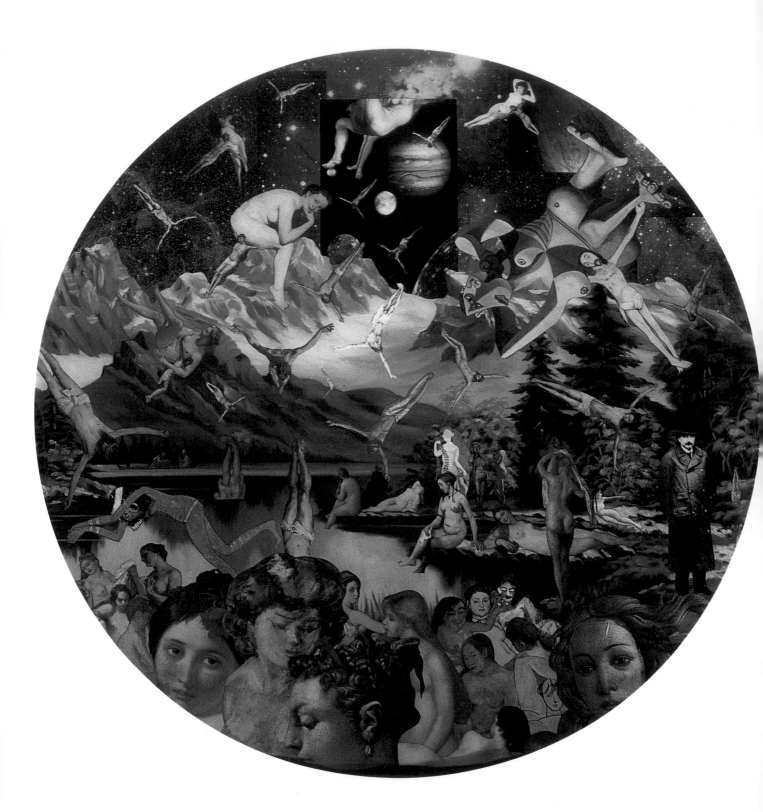

Relativity

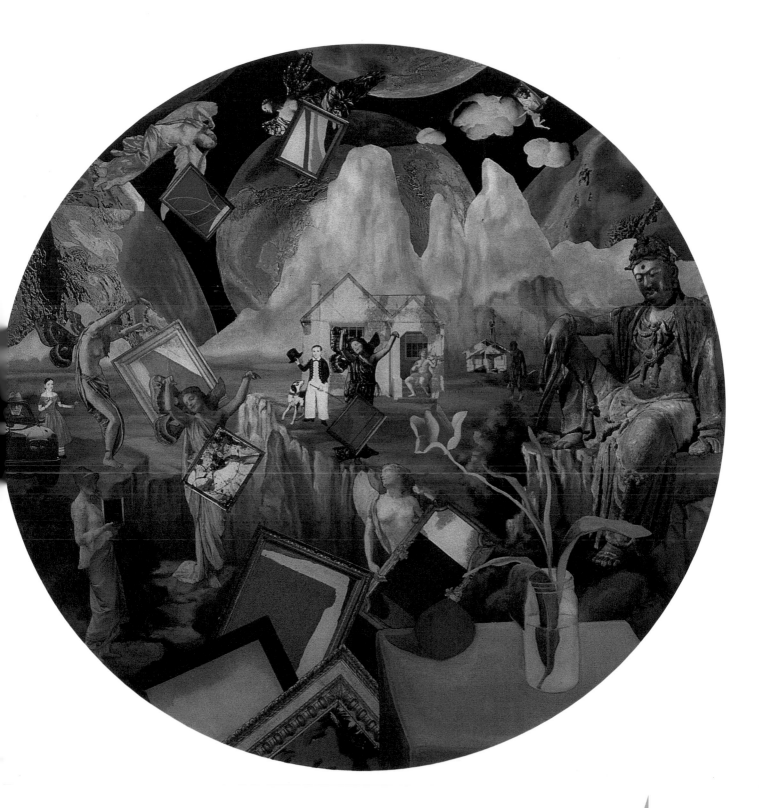

Still Life with Psychoanalyst

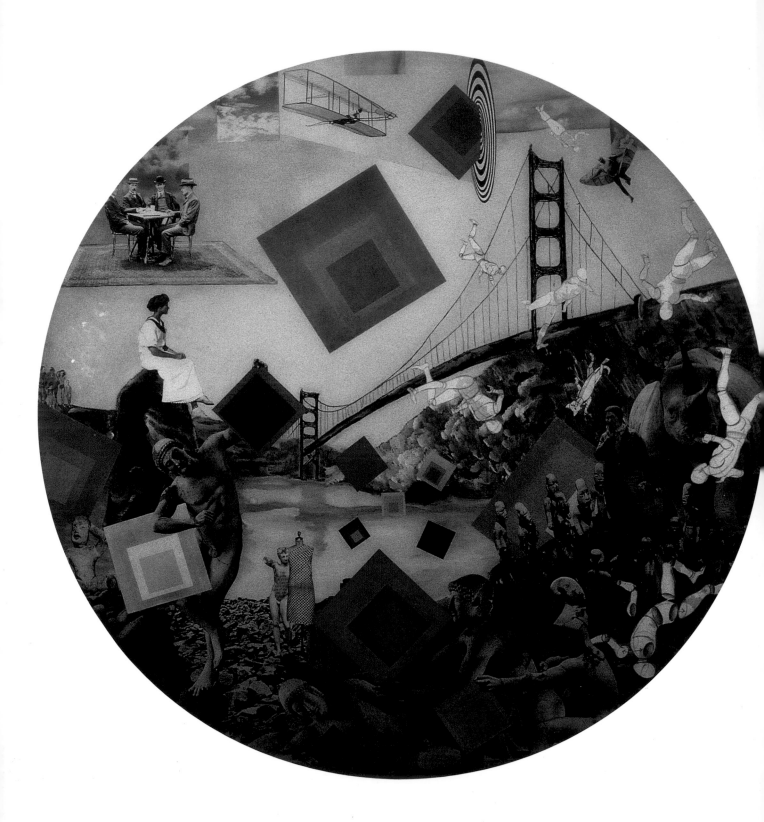

Under The Bridge